A
HISTORY OF
CONNECTICUT
WINE

Vineyard in Your Backyard

ERIC D. LEHMAN & AMY NAWROCKI

Charleston London

THE
History
PRESS

Published by The History Press
Charleston, SC 29403
www.historypress.net

Cover photos courtesy of Wally Kolek, Saltwater Farm Vineyard, and the authors.

First published 2011
Second printing 2011

Manufactured in the United States

ISBN 978.1.60949.029.4

Library of Congress Cataloging-in-Publication Data

Lehman, Eric D.
A history of Connecticut wine : vineyard in your backyard / Eric D. Lehman and Amy
Nawrocki.
p. cm.
Includes bibliographical references.
ISBN 978-1-60949-029-4
1. Wine and wine making--Connecticut--History. 2. Vineyards--Connecticut--History. I.
Nawrocki, Amy. II. Title.
TP557.L475 2011
663'.2009746--dc22
2011003223

Follow me back to the vineyard,
back to the slopes of distant suns
when goat herders and pharaohs
tasted the first ripe grapes, full
with the day's breath. Follow me to ancient
altars, to fire-kilned jugs, to weddings
under grand, trumpeting tents.
Follow me across a foreboding sea,
to new soil, through grafted roots, down
into the wellspring and up again
into the heavy red of sugared globes.
Sip as we gather, clustered around
the fireplace, laughing in the bud
of evening light, sharing the extract
of conversions: sun and soil,
water and time. Raise your glasses
toward the moon, the approaching suns,
the human song held in the sweet
memory of wine, and follow me, friends,
into this moment, our mouths curving
into the crescent of a smile.

CONTENTS

Prologue

THE FESTIVAL

It is a thirsty day. Blazing light shines on tall August corn, perfect cumulus clouds hang motionless in a feather blue sky and a soft breeze blows from the far-off peak of Mohawk Mountain. Hundreds of people stroll through the gates of the Goshen Fairgrounds, shielding their eyes from the sun, holding burgundy bags fitted with six bottle-sized compartments. Glass stemware dangles on slings around necks to leave both hands free to explore outdoor stalls selling crêpes and sausages, beads and jewelry, flowers and vegetables, all brought by Connecticut farms and local craftspeople. Live performers and radio DJs take turns filling the summer air with music. But though enjoying both entertainment and provisions, the throngs of people are not here today for cheese or chocolate. They have come for the wine.

Inside the crowded farm buildings we find the real action. The vintners and owners behind the display tables bubble with eagerness and encouragement: "you might like" or "here's what we have to offer" or "try this." Tasters jam the counters four thick, waiting to try the next unique flavor. Some are here for their first tastings, overwhelmed by the choices, and some are veterans, picking wisely amongst the wines, narrowing to a favorite vintage or grape. All need a certain amount of dexterity in the swirl of hands and faces, to be in position to raise a glass to waiting lips.

For lunch, we munch on farm burgers and hot dogs, made with locally grown, natural beef, paired with a dry red blend of merlot featuring notes of cinnamon and vanilla. NPR T-shirts mingle with straw hats. Collies rub noses with Chihuahuas. Three women at the next table all wear wine-themed T-shirts; one reads, "Pick me, squeeze me, make me wine." A man in

well-worn farm clothes and a woman in a designer dress sip their drinks, eat steak kabobs and talk of the good life. What unites these people? The shared knowledge of a secret—that our state produces great wine.

Since colonists found wild grapes in their backyards, we have always crafted wine in Connecticut. But in the past few decades, large commercial vineyards sprang up across the landscape, becoming both an important force in agriculture and a draw for tourism. Now, in the twenty-first century, we can taste grapes like frontenac and corot noir, vidal blanc and cayuga. A cabernet franc that hints at mocha. A lemony blend of chardonnay and seyval blanc. Wines we tasted and liked years ago we now love. Vintners are focusing, concentrating their powers, trying to get the fields and formulas right. Not only is local wine thriving, but a whole culture has sprung up around it.

This success naturally leads to questions. What grapes actually grow in this climate? Who are these intrepid owners and winemakers, fighting against the forces of historical perception? How will this development change our regional palate? How does this open our minds to the way we think about the future of the state? And how does this change our experience of wine, now that instead of in a café in Paris or a shop in Santa Barbara, we find it in our backyard?

Events like the Connecticut Wine Festival help set the record straight. They also whet the appetite, encouraging thousands of us to travel the gray gravel roads to the vineyards themselves, to become part of this unfolding history. Enthusiasts now drink bottles of local blends to celebrate a wedding. We meet new friends at a farm dinner or gather around a tasting bar with old friends to share a fresh interest. We watch kayakers paddle the shoreline from a vineyard deck and listen to sweet chords of folk guitar as the sun sets over a vine-clothed hill. And we are tasting, always tasting, a white, a red, a rosé, a sweet dessert, oaked and unoaked, barrel-aged or bottle-ready, wines made with genius, with alchemy, with love.

You might wonder what these magical drinks of the hills and shores taste like. How to say this without pride? Like Connecticut.

1

WINE YANKEES

Preparing to sail to a new world, the early English Pilgrims weighed even the smallest objects, deciding what necessities could be squeezed into their trunks: a winter cloak, a good knife or perhaps a Bible. In 1634, worthy Puritan William Wood suggested that a passenger who could afford to do so should also carry "a good Claret wine to burne at sea." When thirsty pioneers like Wood reached the new lands, they were pleased to find ample vines loaded with red and white grapes straying into their new backyards, wandering around Native American villages and tumbling down the high banks of the Quinnehtukqut River.

As settlements grew, wine quickly became a staple, made from these wild grapes "gathered from thick vines edging the woods of every colony." In 1639, the Saybrook settlement took George Fenwick's grapevine seal as its own, and five years later it became the seal of the larger Connecticut Colony. By the time they merged with New Haven in 1665, three grapevines in the center of a shield officially stood for good luck, felicity, peace and the three united colonies. Unofficially, they stood for the state's most abundant fruit.

Wine was brought hot and mulled to preachers during their long sermons, given to children as medicine and shared around the campfires of men hunting beaver and deer. At a funeral, eight gallons of wine and a barrel of cider were not unusual. Coffee was practically unknown then, tea rare and grain too precious as food to use for ale. Water itself was dangerous unless boiled, and the fermented juice of the native fox grape was much more palatable. This sweet brew sustained many families on the long winter nights of the seventeenth century.

Sugar to add to the fermenting vats was expensive, however, and barrels and glass bottles hard to come by. By the 1700s, "Yankee" traders were hauling shiploads of rum from the West Indies and claret from France to complement the rich diet of wild game. Soon, madeira, port, sack and cream sherry became available for purchase at gathering places like the Oliver White Tavern in Bolton. As apple orchards became omnipresent, families began to drink hard cider with every meal. By the turn of the century, workers in the new industrial factories acquired the strange habit of drinking coffee on their lunch breaks rather than alcohol, and fewer people brewed their own wine.

That is not to say they stopped drinking. Alcohol consumption in the early 1800s was much higher than today, and the tavern was a central part of rural Connecticut life. Even those people living in more populated areas kept their own equipment for making cider, brandy and wine, and trellises of vines were common. For example, in Bridgeport, a large vineyard was "flourishing" in 1827. A year later, the *Norwich Courier* encouraged farmers to turn from the simpler apples to grapes, since "a good crop may be expected every year; besides the juice of the grape will improve by age."

By 1858, it was said that "the culture of the grape and the manufacture of wine or rather syrup from our native grapes, is beginning to be a source

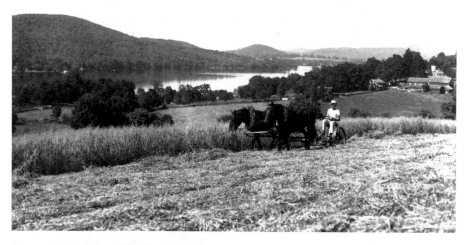

Farmers like William Hopkins had the perfect site for growing wine grapes, but another hundred years would pass before Connecticut would achieve its potential. *Courtesy of Hopkins Vineyard.*

of remunerative employment in Connecticut." Enough people were growing grapes in large quantities to stage a Grape Growers and Vintners' Convention on January 13 in Meriden. David Clark of Hartford opened the convention, giving advice for winemaking and calling for a permanent Vintners' Association to be formed. They resolved to expose adulteration and fraudulent wine and continue to "make a pure article." Lectures on grapes were given at the Yale Scientific School, with five hundred students attending one in 1860, and growers began holding regular meetings to discuss their methods.

One of these farmers, George A. Wells, grew pears and grapes on the gentle slopes of Black Rock, now part of Bridgeport. His four thousand vines produced mostly concords but also other varieties like clintons and adirondacs. Wells fought the tiny aphid-like insects that would later be called phylloxera and planted rows of carrots and potatoes between the vines. Careful pruning kept the long rows of beautiful fruit productive, and by 1868 Wells had received adequate returns. In his barn, the grapes he did not sell immediately were pressed to make wine, and barrels were kept in huge cellars carved out of the hill of Black Rock.

Vineyards soon sprang up in Middlefield and Branford. In Waterbury, A.B. Wilson's vineyard on Riverside Road produced tons of grapes. The 1863 agricultural fair in Rocky Hill featured several varieties of wine. Vineyard owner Ashbell Belden proudly passed decanters around for all to taste, and they pronounced it to be a "choice production." And in 1872, John Dickerman of Mount Carmel gave an award-winning report to the Board of Agriculture, saying honestly, "No one now will pretend to classify the vine and its products as an element of much importance in the aggregate amount of her agricultural productions." However, he pointed out hopefully that "the object of this treatise is to show how it may become second to none."

Dickerman detailed a decade of wine production on the south slopes of Sleeping Giant Mountain in Hamden. The first vines were planted in 1860, and after the first few years he pruned them to the desired size and shape. In 1864, his concord and clinton grapevines produced over ten pounds per vine. He found that the six acres of "rough, hard, hill-side pasture," which had not even yielded a crop of peas, produced huge clusters of grapes. The dry air of the "worthless" hillside complemented the perfect drainage of the Giant's trap rock. He hired a German "vine dresser" and learned from him how to care properly for the grapes. By converting the fruit to wine, Dickerman tripled his profits in a year. "The production of wine is a matter of vast importance," he assured everyone.

In response to Dickerman's essay, the *Hartford Courant* wrote, "Farmers under Bolton, or Talcott Mountains, struggling with natural difficulties to produce a fine tobacco wrapper, might take their cue from the Mount Carmel grapes." Many around the state did take up the project, trying the ives grape, as well as the hartford prolific and concord, to great success. Mr. Coples of Danbury hybridized grape varieties, producing one in 1871 that he hoped would "prove hardy and free from mildew." At the 1876 centennial exhibition in Philadelphia, W.N. Barrett of West Haven and C.E.B. Hatch of Cornwall displayed grapes in Connecticut's booth as one of its important products. George Wells's Mapleside Vineyards in Black Rock also continued to thrive throughout the 1870s.

As early as the 1830s, temperance reform began to be taken seriously but remained largely in the background of everyday life. However, by the turn of the twentieth century, anti-alcohol groups became more powerful, and laws restricting wine and other liquor began to be passed. In 1903, a law was argued before the state senate that read, "Wine made [from] grapes grown in this state, at places where grown, may be sold in licensed towns in quantities not less than one gallon, and in non-licensed towns in quantities not less than five gallons, to be delivered at one time and not to be drunk on the premises." This effectively killed any retail sales the wineries might have hoped for. The farmers who owned vineyards, some of which covered "as much as eight and ten acres," argued that such restrictions would hurt them since the rocky soil could not be planted with anything else and that the "growing of grapes with the intention of making grape wine was promoting home industry."

Despite these tensions, as Italian and other southern European migration increased in the early part of the century, winemaking in the state increased tenfold. As Dickerman said decades earlier, "The excellence of our home productions should be made known and exemplified by America's adopted citizens, whose happiest recollections of their father land are associated with the wine and its generous fruitage." Every immigrant family proved him right with a plot of land loaded with grapes to make wine. Along the Berlin Turnpike, "extensive vineyards" sprang up, at least three of which became commercial ventures. Some took it to another level, going beyond even what the ambitious farmers of the late 1800s had done. In Meriden, an Italian American named Dominick Dondero developed a large vineyard. Taking a swampy wilderness, he cleared the land, drained off the water and filled in the swamp. He planted twenty acres with grapes. Many were bought by other local winemakers and turned into tasty Connecticut wine.

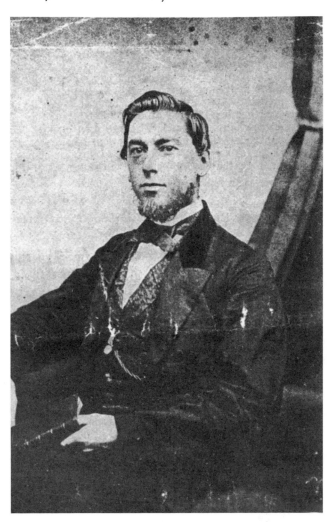

During the late 1800s, Jonathan Dickerman's vineyard on Sleeping Giant in Hamden grew native wine grapes and found some success with *vinifera*. *Courtesy of the Hamden Historical Society.*

The most successful of these vineyards was started in 1908 by Pasquale D'Esopo, an Italian banker. He bought the Dickinson farm in Marlborough, near the boundary line with Glastonbury. Two years later, the farm had seventy acres of grapes under cultivation. He brought a vineyard manager from Italy named Joseph Sena to oversee the production. They grew concords, which D'Esopo claimed were not that different from those in Italy, mixing them with small quantities of other grapes grown on the farm, such as wordens, to make a Chianti blend. D'Esopo's "Mountain Top Vineyard" reached over nine hundred feet at its highest elevation, and the grapes thrived on the rocky hillsides. At first selling most of the grapes, he gradually

used more and more for making wine. By 1915, over eighty acres had been planted, and the vineyard was producing three tons of grapes per acre.

Worries amongst the farmers grew as Prohibition became likely. This was a vital concern for the state, as the *Hartford Courant* of 1919 explains: "It is impossible to ride any distance in this state without coming upon vineyards… the native wine product of Connecticut must be large." The paper asked, "Will everybody who has wine made from his own grapes be attacked by the government?" Perhaps not everybody, but the Eighteenth Amendment was enough to dry up this encouraging spread of native winemaking in Connecticut. By 1922, the state was importing huge numbers of grapes from California, ostensibly for eating, and the vineyards went into a steep decline, disappearing from the landscape and from our collective memory.

Even after President Roosevelt lifted Prohibition in 1933, local laws continued to make commercial winemaking impossible in Connecticut. Nevertheless, immigrants continued the tradition of planting small grape plots, making up to two hundred gallons of wine. Some farmers tentatively made small batches for friends and family. In the 1950s, on their farm in North Grosvenor Dale, Mary and Peter Kerensky first cultivated both berries and grapes to ferment for home consumption. However, it would be another twenty years before they would be able to share their St. Hilary's wine with the public.

Finally, four decades after Prohibition's end, Sherman Haight of Litchfield led the way out of these dark ages into a new revolutionary age of winemaking. In 1974, he gave up sheep and beef cattle and decided, against all advice, to grow European *vinifera* grapes, planting chardonnay and riesling along Chestnut Hill Road the next spring. For a year, Haight studied with the famous Dr. Konstantin Frank, learning the methods of winemaking already in full force in New York's Finger Lakes. He lobbied the Connecticut state legislature to allow growers of grapes to produce wine on farms. Then, with the signing of the Farm Wine Act by Governor Ella T. Grasso in 1978, Haight bottled his first wines.

Dr. Paul DiGrazia of Brookfield had already joined this bold action. According to his wife, Barbara, he said, "We're going to plant a few grapes and do a little farming." Master of understatement, DiGrazia put in fifty acres. A small family winery in Stonington called Stonecrop also anticipated the change, setting up shop in 1977. Once the act passed, the Kerenskys officially opened their small St. Hilary's Winery to the public in 1979, selling fruit wines out of a converted carriage house. McLaughlin Vineyard and Clarke Vineyards opened that same year, followed by Crosswoods, then

Hopkins and then Hamlet Hill. By 1984, Connecticut was the leading wine-producing state in New England.

These pioneers had little to go on when it came to deciding what to plant and how to care for it. "We made a lot of mistakes in the beginning, but hopefully we didn't make too many twice," said Haight. Gerald Walton at the Connecticut Agricultural Experiment Station in New Haven dedicated resources to the problem, planting fifteen varieties in the first two years. The farmers tried American, European and hybrid grapes like seyval blanc. Haight's winemaker, Shorn Mills, used seyval to make the state's first Champagne-style wine, following every step of the traditional "méthode champenoise" to produce a classic dry *brut*. By that time, winemaker Howard Bursen at Hamlet Hill won the state's first competitive medals.

Thanks to these pioneers of the late twentieth century, Connecticut was now set to fulfill the dream of long-ago visionaries like John Dickerman and Pasquale D'Esopo. Certainly, the way was not easy. There were still regulations to be fought, prejudices to be overcome and challenges of weather and disease to meet. "The grapes struggle here and that adds to the quality," Sherman Haight declared. The same might be said for the dreamers and pioneers who struggled to make the long-deferred hopes of Connecticut wine a delicious reality.

2

THE VINEYARDS OF HOME

Those who call Connecticut home are always eager to share Mystic's tall ships, New Haven's pizza, East Haddam's Gillette Castle and Hartford's Bushnell Park. At the end of an extensive list of attractions, we can now include the state's growing number of vineyards and wineries. And yet one question still sneaks from the lips of travelers and locals alike: "We make wine *here*?"

Wineries appear in every state in the country, and wine can be made from a variety of fruit in a variety of settings. Easily accessible at restaurants and liquor stores alike, wine adds sparkle to meals and gatherings and helps us toast and celebrate. Corked and foiled, a bottle appears on the table ready to open; we often forget how it got there or came to be. Where did this magic begin, and what can be found by tracing its origins? Answers may be found by visiting the places where wine is produced. And since many wineries involve some effort to find, the discoveries go beyond exploration of processes and sampling fine wine. What about the ones seemingly right around the corner? Why visit a *Connecticut* winery? We are often surprised by what is in our backyard.

Getting to a vineyard nestled in craggy trap rock hollows is not as easy as the GPS coordinates may indicate. It may take a half-life in one's hometown before the opportunity to visit a neighbor materializes. A day on the Wine Trail with Cheshire residents Sarah and Ron Kearns brings us to McLaughlin Vineyard. Sarah and I grew up in Newtown, have been friends since kindergarten and now are both newlyweds. Rediscovering the site that was only a few miles from our childhood homes, we bring our husbands to our hometown vineyard. We get lost as we twist from the heart

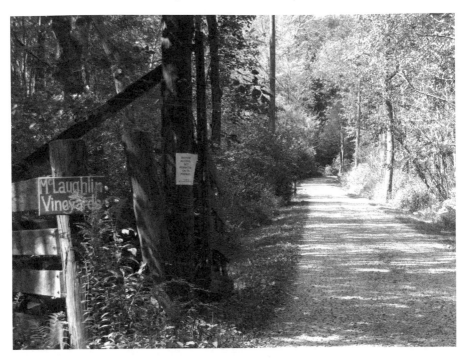

Tucked away in Sandy Hook, McLaughlin Vineyards borders hiking trails and an eagle sanctuary. *Courtesy of the authors.*

of Sandy Hook down Albert's Hill Road. The Housatonic River is just out of view as the meandering way rises and then falls again. The vineyard's painted sign is easy to miss, and it's hard to believe that at the end of this path is a winery, one that has been operating since the state first made it legal to make wine commercially.

A late September sun parches the road that winds toward what seems to be only another collection of oaks, maples and sassafras trees. Fallen leaves parceled by summer's end begin to slowly collect by stone walls. Along an old fence, goldenrod and ferns take turns bracing against a soft breeze. As the car slows to navigate another turn, the low slope of hills begins to open, and the unmistakable sculptures of grapevines come into focus. There is an invitation ahead: stone steps ascend to a terrace where black-latticed patio chairs and tables welcome tasters and travelers. A bluegrass band harmonizes beneath a white tent. Inside the restructured old barn, there is a small country market, selling honey, light green speckled eggs and maple syrup collected and boiled in the nearby sugar shack, which opened in 1998. Around the corner, a tasting awaits.

Beneath a giant mural of eagles swooping in to land, Bruce McLaughlin, attired in a light-blue button-down shirt and Red Sox cap, blends in like a regular, taking a seat around the glass-topped wine-barrel table. Bruce speaks with a casual sense of pride about his plans to further investigate the characteristics of the norton grape. He reminds us that the farm's 160 acres share land with the Upper Paugussett State Forest, where rare eagles nest. On a cold February day, you can hike the trail that runs through the vineyard and hope for a winter sighting. With fifteen acres of vines, the winery produces twenty-five hundred cases a year. We begin with chardonnay, off dry, oaked slightly with hints of pear and apple in the middle, a little butter on the finish. Blue Coyote offers a ginger candy nose and apple notes in the middle. Bruce tells us the grapes, among them vidal and aurora, are planted near green apple trees and may impart the fruit's perceptions we find in the wine.

Growing up in Newtown, I remember the note of recognition and local interest when McLaughlin Vineyard opened to the public. When my brother Kris signed up for a part-time gig as a maintenance worker in 1988, the vineyard had been operating for almost a decade, since Bruce began planting in 1979. Probably more interested in making a few bucks and working with his buddy Greg, Kris hardly recognized the pioneering actions of the founder. Under the watch of Greg's father, Randy, who was manager at the time, the boys set to work pruning and tying vines, raking and clearing brush, unloading and stacking boxes and painting. Kris remembers harvesting grapes in middle school. "It was one of my favorite places to go," he reflects. "The land was awesome."

As a youngster herself, Morgen McLaughlin Smith, Bruce's daughter, remembers helping her parents plant the grapes. Bruce began the vineyard in order to safeguard the land and preserve it as a place for agriculture and outdoor activities. Newtown, like many of the towns in the state, had been losing agricultural land for decades. Even as the manufacturing of furniture and fire hoses took shape, farming continued as the primary livelihood of Newtown. Nearby Ram's Pasture, a mere few miles up Church Hill and past the flagpole, had been the central meeting and agricultural site since the town's founding in 1705. Two and a half centuries later, when Charles McLaughlin, Bruce's father, purchased the nearby farm in the early 1950s, he understood the land's infinite possibilities. But as any farmer knows, unused or neglected, land will fail or fall to developers. As more and more land is urbanized, wineries like McLaughlin help keep land in agriculture. As Morgen explains, the winery was opened in part to tackle these very

issues. Now, visitors can share the experiences of tasting wine, explore the vast acreage with a hike and eagle watch, enjoy outdoor music or vintage baseball, watch tree sugar turn into amber syrup and connect again with friends, family and the nostalgia of hometown familiarity.

Bruce started planting right away after the law changed. After building a research corporation while in his thirties, he turned his enterprises back toward farming and eventually viticulture. He has also developed the wine industry across the country in Colorado, opening Minturn Cellars, named for the small railroad town between Vail and Beaver Creek, in 1990. The McLaughlin home serves as the tasting room there, and like its Connecticut counterpart, Minturn offers a picturesque spot for tasting and gathering. Both states were once thought to be odd choices for commercial winemaking, but since Bruce first began, growth has followed in both. More recently, Bruce has let Morgen take over most of the day-to-day operations, and keeping the land and the vineyard in the family means a great deal to them. As Morgen raises her own family, she works to improve the winery and its offerings for others to enjoy.

Visitors and residents agree: "It is hard to imagine a more idyllic location than the stone patio at McLaughlin Vineyards on a Sunday afternoon," says Newtown resident Rebekah Harriman. "Live music, fantastic wine, against the backdrop of the gorgeous vineyards—it doesn't get better than that. We are thrilled to have such a gem right in our backyard!"

Whether our visits are frequent or once in a lifetime, a winery is a perfect venue to experience something new in an atmosphere that evokes the comforts of home. Bringing people together is at the forefront of Linda and Dick Auger's minds at Taylor Brooke Winery in Woodstock, where, like at wineries across the state, the owners understand that visitors want to connect to the place, want to feel comfortable, just like home. This filters to their wines and even their labels, designed by local artist Thomas Maynard. Nearly everything that goes into running their business is meant "to help support each other and our community."

When considering where to build their winery, the Augers knew they wanted to stay in their hometown, preferring to build on something that had been farmed before, so they settled on the Taylor farm, which spreads out by a forested brook, hence the winery's name. Building the tasting room right next door to their house simply made sense to them. With tables in the front, back and inside, everyone is welcome to bring a picnic lunch or sample the local items the tasting room sells, like cheese from Beltane Farm or meat from Bush Meadow Farms. After redoing the front patio of the

tasting room, Linda even lets people use the big picnic table on the house porch. "The idea is that it's a little more homey," she says, "and you really feel part of our family—that's what we're going for. We want people to feel comfortable." With winery dogs Zima and Georgia roaming between the vines, guests cannot help but feel relaxed and welcomed. "Wine should be fun," Linda muses.

Once at ease, tasters are ready to sample wine and perhaps try something they might not have considered. "When you go to a winery," says Linda, "that's a great opportunity to try something a little out of your comfort zone, and you might be pleasantly surprised." For those who go for the sweeter wines, their Green Apple Riesling offers the zing of apple essence without a syrupy overtone. For someone who might be a little tentative to try a riesling, thinking it might be too sweet, Linda might suggest Woodstock Hill White—a blend that is drier but still light. To encourage more converts, Linda suggests trying another vineyard's fruit wines: "We want to develop not only the repeat business, but we want to develop their palates along the way." After all, the main reason to visit wineries is to taste some really great wine.

And great food. Gathering at a vineyard is an opportunity to visit with friends and family, converse with the winemakers, soak in the scenery and satisfy the heart and, of course, the belly. On another September day in Goshen, Miranda Vineyard hosts its first annual pig roast. Manny and Maria Miranda opened their winery in 2007, but winemaking had been part of his family for as long as Manny can remember. Growing up in Portugal, he learned every aspect of the process from his father and grandfather, and once he and Maria retired, they turned their attention to developing the winery and making quality wines in traditional styles. Since they began planting in 2001, they've cultivated such varietals as leon millot, st. croix, vidal blanc and chardonnay. The tasting room has been renovated since they first opened to include welcoming tables spread out over a glossy hardwood floor.

Eric's parents, David and Trena, join us in the blaze of an afternoon sun under a white tent, tables with red checkerboard coverings filling with diners. Bales of hay line the outer perimeter of the tent, and mums in mason jars decorate the tables. Children roam as cameras snap. In front of rows of vines under a slanting afternoon light, a quartet—including an upright bass, fiddle, mandolin and guitar—plays singalongs and old favorites.

For dinner, we enjoy the promised pig, served with roasted potatoes, a medley of seasonal squash, airy soft dinner rolls and a mixed green and

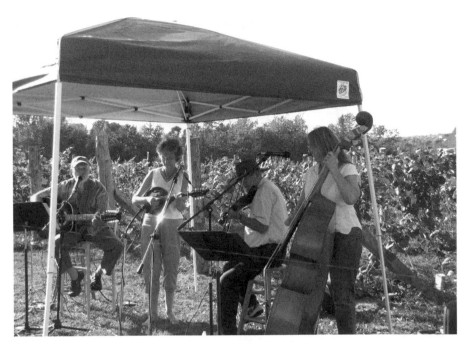

Autumn vines provide a backdrop for Corey Bush and Friends as they play a unique blend of bluegrass and folk at the first ever Miranda Pig Roast. *Courtesy of the authors.*

tomato salad. In the family-style atmosphere, everyone relishes the food and wine. With its light earthiness, Farm House Red wine pairs nicely with the rosemary in the potatoes. With Woodridge White, we eat apple cake with whipped cream, and again the wine seems perfectly matched. This blend of chardonnay and seyval blanc, with its slight cinnamon nose and peach notes, complements the dessert, which is not too sweet. Conversations and smiles accompany the meal.

As the sun turns a woody hue over the vines, a couple dance and friends join in, pantomiming as they all take turns dancing, each time playfully sticking a dollar into the man's plaid shirt. Everyone laughs, and in good humor, they give the proceeds to the band. Twin boys steal the show, jitterbugging in time with the band and the clapping audience, their matching shirts reading, "My favorite color is dirt." Eric clowns with the crispy pig ear, and his mother laughs. His father compliments the drinkability of the complex Miranda wines. The Lehmans are newly transplanted to Connecticut, and they, like others, enjoy gatherings like this one as a chance to explore their new state, taste wine and spend a day with family in the open air.

These scenes of laughter and conversation manifest every time we settle into the end of another season and toast to the privilege of sharing food and wine with loved ones. Why visit these out-of-the-way venues, nestled near brooks, among clover and beyond sassafras trees? To reacquaint with neighbors, to rediscover the backyard, to forge into places new and old. The band sings Harry Chapin's "Circle," and we celebrate: "Let's go round one more time." Welcome home.

3

EARLY VINTAGES

On a forested country road in New Preston, a red fox scurries alongside our car into the woods. In a few minutes, we wind around the shore of Lake Waramaug, named for a Wyantenock Indian chief whose tribe summered there. Today, others follow in the Indians' footsteps, boating and fishing for bass, trout and perch. Above the lake, the 1847 Hopkins Inn serves tasty Austrian cuisine, and summering tourists sit in Adirondack chairs between vineyard and lake. We pass the inn and find a spot to park near the rows of vines. It's May and time for Hopkins Vineyard's annual barrel tasting.

On the slopes near the vines, groups of friends relax on blankets under the warm sun, listen to a band, eat Cotswold cheese and sip Westwind White. Under a large tent, we join the throng sampling two-year-old chardonnay and bin-fermented cabernet franc. Bill Hopkins stands with his winemaker, James Baker, behind two barrels with anonymous, half-full decanters. "Born" and pressed in previous years, now tested for its complexity and readiness, these wines allow us to taste the process, to get those first notes of future symphonies. The cab franc is not close to being finished but already hints at greatness.

We try a vanilla and pepper Red Barn Red while watching barn swallows chase each other across the pond. James says Red Barn is a "farm blend" of baco noir, marechal foch, dechaunac and cab franc. Only through experimentation can blends be achieved at all. By switching cab franc to lemberger, Hopkins creates Sachem's Picnic, a sweeter, summery wine. This is an example of how the winemaker can choose a consistent result that he or she is looking for, despite the way grapes and wines change from vintage to vintage.

Comparing three different vintages of Hopkins's Estate-Bottled Chardonnay finds remarkable similarities, especially in a region known for inconsistent weather. All were smooth, with similar taste structure from start to finish. But the middle year, 2006, had pear notes not present in the other two. Over five years, their estate-bottled cabernet franc changed slightly, consistently remaining peppery and buttery but sometimes having notes of pipe tobacco, cherry, mushrooms or flowers. These changes are to be expected, and desired, from year to year. But we noticed that Hopkins's blends, easier to regulate, also sometimes changed from year to year. Made with pinot noir, lemberger and dornfelder, the Lady Rosé always tastes of strawberry, but one year we detected pipe tobacco on the nose, and another year the finish had a buttery caramel flavor. The West Wind developed from a very sweet, peachy wine to a drier, citrus-apple blend. Only the Duet, a vidal blanc and chardonnay blend, was consistently floral and fruity, with notes of peach and pepper. That exception proved the hypothesis: Hopkins Vineyard could be consistent even while experimenting and allowing the vintages to speak for themselves.

Nothing represents this tension between consistency and experimentation more than Hopkins's farm itself. Returning from the Revolutionary War, Elijah Hopkins founded the farm in 1787. His son William opened the house to boarders in 1846, drawing visitors from the new Housatonic Railroad in the 1870s. In 1895, William's son George founded the Sachem Inn, combining farming with innkeeping. Over the centuries, this farming family grew tobacco and raised sheep and horses, whatever yielded the most profit, experimenting with the land while remaining faithful to traditions. Current owner Bill Hopkins grew up in Sachem's, tending herds of dairy cattle. But by 1979, Bill and his wife, Judy, found the dairy farm no longer profitable. The high price of milk and the distance traveled with equipment grew more every year. However, Bill "wanted to keep the land in agriculture." So he auctioned the herd of cows and planted vines.

The Hopkins family had always made dandelion wine, mostly to keep the kids busy. "I remember when I was really little having to pick the dandelions—it was torture," says daughter Hilary. Sherman Haight had recently planted his vines in Litchfield, but this was "kind of new ground; I think the neighbors thought we were crazy." The winery opened to the public in 1981, three years after the farm winery act. After being told *"vinifera* will never do well here," their first plantings were mostly natives and hybrids: labrusca, aurora, cayuga and seyval. Later in the 1980s, Hopkins began to grow chardonnay, initially for sparkling wine, "because the thinking at the time was that you couldn't get it ripe enough

As young boys, Bill and Steve Hopkins had no idea that their farm would become one of Connecticut's premier wineries. *Courtesy of Hopkins Vineyard.*

to get a still wine." With the help of Richard Kiyomoto, who has investigated wine propagation with the Connecticut Agricultural Experiment Station, they became the first in the state to plant the now ubiquitous cabernet franc.

During those early years of Connecticut's new wine industry, experimentation was the norm. Organizing the "grape people" was one

of Bill's priorities, and he and Sherman Haight were joined by Dr. Paul DiGrazia. This gynecologist originally from Paterson, New Jersey, created DiGrazia Vineyards in Brookfield in 1976, also owning a vineyard right over the border in Armenia, New York, and planting more grapes in nearby Southbury. He also keeps vines behind his beautiful but modest home on Tower Road, with its patio, pergola and waterfall framing a tasting room. Nearly a "spiritual calling" for DiGrazia, the idea came upon him quite suddenly, though he had wanted to work a farm since he was a child. Now, he spends his free time researching why winemakers live longer.

The few acres behind the house are just enough for the wine DiGrazia makes for cathedrals and seminaries. And though his main vineyard is barely twenty miles from his home in Brookfield, he is forced to put "American" wine on the label. Some might complain about this geographical injustice when California wineries often get their grapes from hundreds of miles away. But regardless, as one of Connecticut's wine pioneers, Dr. DiGrazia has earned a unique place in the history of our wines through his ingenuity and persistence.

For one thing, the wines he makes have very low sulfite levels, far below the legal limit, perfect for people with allergies. His Honey Blush uses added honey rather than sulfites to combat mold and bacteria. He also makes an amazing port. We tried the six-year-old Blacksmith Port, aged one year in American oak, finding it complex, no heavy nose or alcohol taste like some ports, with toasty caramel notes and a chocolate finish. Simply one of the best ruby ports we've ever tasted, no matter the age, price or place of origin.

DiGrazia found that the key to making good wine here was the durability of the grapes grown. "You need a hardy variety that can resist the hot mildew in the summers, which can be a problem. And the winter can be a problem," he said. However, as the years passed, he found that "our soil is very acidic and lends itself to winemaking." He also found that by keeping his winery small and filling a niche market, he could do more than survive; he could make good wine. Not all the early pioneers were so fortunate. Thomas Young of Stonecrop Vineyard in Stonington couldn't make a profit and folded after five years. The Kerenskys of St. Hilary's Vineyard held on until 1991. But DiGrazia and Hopkins did survive, and their success may have followed their constant experimentation, their quest to find the right combinations of agriculture and chemistry.

A few months after the barrel tasting, Bill Hopkins comes in to the wine bar from mowing the fields, doffing his baseball cap and greeting us. His daughter Hilary and James Baker are already talking to us about the need

for constant change. "We do want to experiment," says Hilary. "If you don't, you're stagnant," agrees James. But for Bill, experimentation is a necessity, a method of survival. But so, paradoxically, is consistency.

He tells us how he and Sherman Haight drove together to the state legislature in Hartford to wade through the quagmire of laws. A lot needed to be changed to make it easier for future generations of winemakers. He also had to do the distributing himself. "It sucks. You have to sell your wine at a different rate. Is that something that you're willing to take on?" The distributors fought Bill, Sherman and Paul every step of the way. Sometimes all he could do was "bang [his] head against the wall." But it was worth it so that every small winery now can do what they're doing.

James and Hilary take us through fields of chardonnay, vidal blanc and dornfelder. Down in the hanging valley that leads to the lake are pinot gris and cabernet franc and, across the way, hills of cayuga and seyval. From points on the nine-hundred-foot hill, we can see the lake, two hundred feet below. Hilary says, "I think it's unique to us—we're the only Connecticut winery that has an inland lake." James agrees that "the cold air has a place to go, and that's important." But more importantly for him: "It's beautiful. It's a great place to work because you have that to look at." We wholeheartedly agree. High on the slope, the chardonnay gleams in the sun, while the dark purple dornfelder seems to suck in the light. It is surprising how much variation exists on one farm: the chardonnay grapes at the top of the hill and down near the barn taste different. Nevertheless, Bill stresses the need for consistency. "That's why we prefer to grow our own…to have a consistent quality product, you almost have to do it by yourself."

In the old hay barn, James shows us the barrels of aging wine. He says cab franc and chardonnay do better with French barrels, but that is an added expense. Over the years, he experimented with aging, finding that extended barrel time helps the cab franc. "We're learning in the vineyard, learning in the winery." He also tries new yeast varieties and different cooperages to figure out how various barrel brands affect the wine. "Always try to improve," says James. He is now trying ice wine in small batches. "I tend to do a lot of research before trying a new wine style." He explains that winemaking is about balance, about how much you can risk and how much you can play it safe. "My first thought is, can I do this?" The biggest revelation was not to force your own tastes on the grapes. "Don't try to make it something else," says James, explaining that small changes mean a completely different flavor profile.

Someone who knows this lesson well is Nick Smith of Stonington Vineyards. At the far end of the state, we park on a misty morning by a

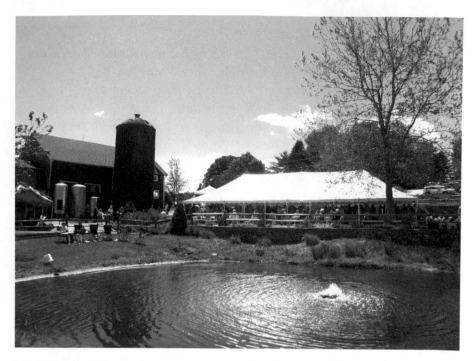

Hopkins's Barrel Tasting Festival provides tasters with the opportunity to get their first taste of future, yet-to-be bottled wines. *Courtesy of the authors.*

long, low barn attached to a cottage rambling organically into each other amidst trellised flower gardens. We compliment Happy Smith on her beautiful petunias, black-eyed Susans and impatiens, and she smiles, talking with a caterer about the possibility of hosting weddings. "There's so much demand for it," she tells us. A few minutes later, her husband Nick meets us in the tasting room, and we open a bottle of their crisp Sheer Chardonnay. Nearby on the floor, propped against the wall at the back of the spacious tasting room, stands a framed poster advertising six Connecticut wineries. It shows wine labels from DiGrazia's Meadow Brook Classic, Hamlet Hill's Wyndham White, Hopkins's "Connecticut Classic" 1986 Seyval Blanc and Haight's 1985 Western Connecticut Highlands Marechal Foch, along with Stonington's Seaport White and Crosswoods 1986 Chardonnay. The poster had been a full-page advertisement in the *New York Times*. Nick asks musingly, "Why would we want to do *that*?"

This vineyard was first owned by Tom Clarke, who planted in 1979. Along with the famous Dr. Konstantin Frank from the Finger Lakes, Clarke founded the American Wine Society. When Tom moved from Norwalk to

plant grapes in 1979, Dr. Frank sent five hundred pinot noir plants to start. The Clarkes had a variety of grapes here: marachel foch, riesling, seyval blanc and Frank's pinot noir. "I think all of us are getting more and more experienced using Connecticut-grown grapes for winemaking," said his wife, Barbara, optimistically. The Clarke vineyard was able to produce two hundred cases of wine on a dirt-floor room.

Meanwhile, Nick Smith spent his early career in the banking industry, when things were "pretty clubby" and "our word was bond." When he was called to work at the World Bank, he and a few friends formed a wine-tasting group. They'd meet once or twice a month and even wrote research papers; the experience got him into wine "big time." Reportedly, he stood up at a party and said, "Someday I hope the wine in my glass will be one I made."

With his first wife, they created a wine cellar in their apartment in Brooklyn Heights. She died in 1981, and he remarried Happy in 1984, working as the executive director of a bank and doing financial consulting. On a trip to his daughter's boarding school in Milton, Massachusetts, the Smiths stopped in Mystic, where Nick grew up during the summers after World War II. "It would be nice to have a house here," he thought. A friend gave a party, and he met Sue and Hugh Connell from nearby Crosswoods Vineyard, who told him to forget the house, buy land and sell the grapes to them. "You make wine here?" he asked them. "We sure do," they replied.

At the same time, Nick's father spotted an ad in *Yankee Magazine*; the fifty-eight-acre property that is now Stonington Vineyards was for sale by Tom Clarke, who was ill at the time. Nick was invited to the house to meet Tom but couldn't go through with the deal just then because he "saw the dream in that man's eye." Tom died five months later, the house went on the market and the Smiths owned it within twenty-four hours.

"I didn't know the first damn thing, but I knew I wanted to do it," Nick says. But his ideas centered on building a brand that reflected the history and character of Stonington. "History in this part of New England is incredibly rich to me, because the places are still alive." Besides finding a logo and labels, he hired winemaker Mike McAndrew away from Haight in 1987. "I paid the money for good talent," he says. He also built the winery into the hillside to create cool, stable temperatures and bought good equipment, taking the fermentation tanks from another early winery, Hamlet Hill, when it went bankrupt. With his background in finance, Nick hoped the same thing would not happen to him.

In those early days, when the present tasting room had no walls or windows, not many people came for tastings. So Nick loaded up his Volvo

and went on the road to sell the wine wholesale. Liquor store owners were often surprised to learn that the owner of the winery was the one selling, but he says, "If I don't do it, I've lost touch. I like to do business face to face." He opened a handful of accounts, working up to 650 buyers in Connecticut, selling 95 percent of the wine at wholesale. However, even selling thousands of cases wholesale, he was not making a lot of money. So they built the tasting room, and now 95 percent is sold there at much greater profit.

Finding what worked for his land was the greatest challenge. Tom Clarke's attempts at pinot noir failed, and Nick also didn't have luck with this difficult grape. Cabernet franc worked better in the soil of the southeastern New England coast, allowing cool, long growing seasons and moderate winters that do not shock the roots. The water also gives a more consistent climate year to year than many other areas of Connecticut. Trained as a geologist at Williams College, Nick found that the south slopes and glacial alluvium did not require tiling because vines could reach down to the high-water table. Over twenty years after his first plantings, Nick has found what grapes grow best here. However, he is now thinking about planting riesling, continuing to try new things even when successful.

Stonington's biggest success has been chardonnays that taste exactly like the fine Chablis of eastern France, which Nick says is much closer to our *terroir* than California. Mike McAndrew uses the traditional Burgundian methods of winemaking, adapting them when necessary for Connecticut. He and Nick work with low yields on purpose, cluster-thinning to improve the remaining grapes. Unlike California chardonnays, "I proved to myself that chardonnay doesn't have to be produced in an oak barrel," Nick ruminates. This way, just the quality of the varietal grape comes through. He tells us this as he warms the too-chilled glass in his hands. He instructs us to let the wine linger a little "right behind the wisdom teeth" to get what he calls the "slatey minerality."

Nick is quick to point out that pioneers like Sherman Haight and Bill Hopkins took the real risks. "I always knew that with these people in the industry it was going to grow." He sees a bright future for the state's wine and says, "If someone has the dream, I would do everything I could to help them." He has everything he possesses invested in his own winery. But there's a reason for that. Stonington's new ad campaign is: "Wine is food for the soul." It certainly has been for Nick Smith.

The risk that Nick admires so much has paid off for Bill Hopkins. He is looking forward to keeping this "family operation" going for the twenty-first century. Hilary says, "I am proud of what my parents did, and I want to

keep this here for my children and their children. This land is very special to all of us." Her siblings feel the same way as she does, but not everyone is so lucky. Sherman Haight's children weren't interested in making wine, and he recently sold his farm to another family.

James, who has been at Hopkins eighteen years, says that pride in the work is what keeps him there. "I learned that from Bill, how much pride he has and what he does with his land." Today, people from all over come to that land to buy wine and enjoy the vineyards. Hilary says modestly, "I think we've made pretty good progress in the last couple years." Part of the struggle has been to educate the local consumers. They take the time to tell people that the wine will be different from year to year and why. "You have to show them that you can do it, and it's all in the bottle. If it doesn't show up in the bottle, no one is going to remember it," says James.

The struggle to produce the early vintages forced pioneers like Hopkins to adapt, to change. But somehow the more things change, the more they stay the same. Bill supposedly turned the operations over to Hilary so that he could spend more time fly-fishing. But as we walk out of the vineyard, he is on the tractor mowing fields, strong and hale at age seventy-eight. We wave to each other, and then he turns back to the work.

f

LIFT A GLASS

S imply put, wine is beautiful. Its beauty enhances even the starkest table, and we cannot help but hear music as it flows into the glass. We marvel at its hues and aromas, touch it to our lips and drink it to celebrate life's wealth. Inevitably, we fall head over heels for this miraculous concoction of fermented fruit juice.

Wine has something else for us, too; it teaches us how to savor. By paying attention each time a glass is poured, as we do in the tasting room when the samples line up for our approval, we become aware. Once each sense is engaged, we journey to understanding and finally enjoyment. We rarely need a guide when it comes to affairs of the heart, but a few words of encouragement never hurt. Notice the subtleties and let the senses be your guide.

While taste may be the most obvious sense involved in the appreciation of wine, the experience is one that involves all of the senses. As with love, sight is the first sense that draws us in. A thin-necked bottle wears a frosted glass dress and reflects off the glossy wood bar of Jerram Winery. Aurora, named for the grape and the Greek goddess of dawn, looks back at us from the label, and a painted green valley calls to her from below the cliff. An etched goblet awaits the quick cascade of glassy liquid. On this June afternoon, the sunlit room illuminates the blend of vidal blanc and the eponymous grape. Like the palest fire, the wine pools around the glass as it swirls. Look at a glass from different angles: across the belly, from the rim and tilted slightly to see how the depth of color changes from middle to edge. More practically, look for clarity and for the tiniest effervescence. Fall in love with riesling's brightness at Sharpe Hill and see the intense starlight in Three Sisters at Rosedale.

Color tells us about the grape's characteristics and the winemaker's methods, and it can predict our response to its taste. Seyval and sauvignon blanc, for example, both appear nearly clear in the glass, with just a hint of summer straw. Cayuga and riesling gleam with touches of gentle lemon. Oak imparts chardonnay with the tiniest amber, while steel seems to brighten it with a metallic sheen. Residual sugar brings out tawny hues in dessert wines and coats the glass like a veil.

Like pink on a cheek after a kiss, rosé simply invites love. Before we know whether sweet or dry will meet our lips, we anticipate the skin's influence with shades of salmon, coral and even bubble gum in the glass. Maugle Sierra's Ledyard House Rosé is the color of pink grapefruit, and Haight-Brown's Barely Blush is primrose with a hint of honey, while their Pink Cadillac is even rosier. The spectrum expands with every visit. Miranda's Rosé is light mauve, while Sunset Meadow's Sunset Blush warms toward topaz rather than pink.

True love is always more than skin deep, but without the skin's touch, red wine would not become the jewel that we love. Like our limited way of calling wine "white," "red" as we know it does not seem to suffice as a qualifier. The grapes themselves, no matter what variety, edge toward the deepest blues and purples instead of red. Hiding behind the green tint of a bottle, the colors appear concentrated, unrealized. It is in the glass that the true beauty comes out, especially at a tasting when only a few sips' worth catch the light. Even one grape, like marechal foch, appears differently depending on the aging process and whether it is blended, as it often is. Jerram's Highland Reserve, a blend that is mostly foch, is a beautiful garnet, while the winery's 100 percent foch appears darker, like plums. Blended with chambourcin, foch has less purple and more vermillion.

Grapes like cabernet sauvignon, zinfandel, shiraz, needing longer growing seasons, show off their thick skins with bold black cherry. Hold your fingers behind the glass and see them disappear. Merlot and pinot noir, with thinner skins, offer lighter hues, more cherry and brick. Connecticut Valley Winery acknowledges the grapes' color in its choices of names. Chambourcin is the primary grape in Deep Purple, frontenac takes center stage in Midnight and cabernet franc wears Black Tie. Spend a few minutes admiring the varieties and the hard work of vintners. Get ready to swirl.

Our ability to taste flavors is mostly due to the fascinating science of our noses. The olfactory system goes beyond our nostrils, as does our sense of smell. The symbiosis of nose, throat and brain is not simple to understand but greatly enhances our experiences. Of the senses, smell connects us the

most to memory, so smelling wine is one way to call up the catalogue of long-forgotten scents for comparison. So we do not just smell wine, which only occasionally hints of grapes, but access an entire world of aromas.

A gentle swirl shakes molecules awake and allows them to travel. Place your nose into the bowl of the glass and let these molecules seep in. Then the fun begins, matching this scent to something the vocabulary of the brain recognizes. Smell, like taste, is a highly individual perception. We detect roses in Taylor Brooke's Traminette and melon in Sunset Meadows' Cayuga, while their rieslings smell like stone fruit or lemon. Heritage Trail blends cayuga with seyval for its Sweet Reserve, and we get peach on the nose. Chardonnay seduces with a range of bouquets, from green apple to citrus, and samples from Miranda's bottle impart nutmeg and, characteristically, butter on the nose.

Reds across the state offer no less in terms of variety. Earthy notes are found in cabernet franc, though the grape also provides vanilla and ample fruit, like the cherry notes we get at Land of Nod. Haight-Brown's Merlot delights with red apple, and Miranda's suggests strawberry and even a little

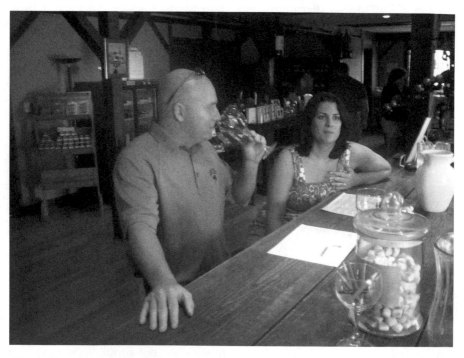

Aficionados Sarah and Ron Kearns check the nose of a white at Haight-Brown Winery. *Courtesy of the authors.*

licorice. Maugle Sierra's Ledyard House Red, a blend of merlot and st. croix, smells of blackberry. We love the violets that come from the French oak in Sunset Meadows' blend New Dawn. The sweetness of pipe tobacco comes out in many blends, like Stone House Red, Gouveia's blend of cabernet franc and merlot.

Now it's time to drink. Our first sip of Vista Reposa at McLaughlin Vineyard tastes floral and fruity. Seconds later, as the wine leaves the front of the tongue, the flavor changes to earthy spice. Finally, after the swallow, lingering notes of chocolate arrive. This complexity compels another sip, and we know that something special happens in a wine where such distinct notes come in just one sip. It is odd to think that our tongues are equipped to taste just five things: sweet, bitter, sour, salty, savory. Mostly sugar, grapes lose much of their sweetness during fermentation, if the winemaker so desires, and it is actually the wine's acid that makes it taste crisp. Too much of either and the results are not pleasing. And like wine's effect on smell, our perceptions of taste are necessarily comparative.

Technically, we taste altered grapes, but we detect so much more on the palate; everything from tart apples, green peppers, orange peel and currants to chicory, clove, vanilla and spice. Even butter seems to be more common than grapes in the body of a wine. We love notes of honey in Haight-Brown's Barely Blush and orange blossoms in Priam's Jeremy River White. Again, the choices made by the winemaker affect the finished product as much as the type of grape. Riesling can be subtly sweet like at Taylor Brooke or deliciously dry as at Priam. Sunset Meadows' Chardonnay finishes with pear and citrus flavors, while Miranda's is spicy and earthy. We seem to get smoky berry and pepper on the tongue with cabernet franc. Stonington's actually has wonderful notes of leather and tobacco. And st. croix can give caramel, black cherry and pepper at Sunset Meadows or tootsie roll chocolate as a dessert wine with Maugle Sierra's Esencia de St. Croix. We even suffer from synesthesia and think DiGrazia's Wild Blue, made from blueberry and apple wines, "tastes purple."

Lips pucker, the sides of the mouth begin to salivate and we link such sensations to taste, but in fact, these are tactile sensations. We perceive sweetness as a taste, but the increased sugar can give wine a viscous feel around the tongue. Indeed, we often comment that a wine has "good mouth feel" or it is "full-bodied," so we are more attuned to touch than we might think when going in to "taste a wine." Anyone who has tasted a grape off the vine can feel the seed's pith on the teeth, and in fact the influence of the seeds, stems and skins affects our perception of tannins, which we actually

feel in the mouth, on the gums and even in the teeth. We sense the lip of the glass, and like the best kiss, we feel the wine as much as taste it.

We practice seeing, smelling and tasting every day, but we rarely process these findings. By recording our reactions in a wine journal, or simply jotting them down on tasting sheets, our scribbles validate our perceptions. More importantly, we have our notes for the trip to the wine store or for the next stop on the trail. Hold a pen in your hand or feel the light tug of graphite against paper as you jot your notes because we cannot forget that touch also has a role to play.

See, swirl, sniff, sip and, as some are inclined, spit. A simple formula is enhanced when we savor each step and take time to relish the labors of love that brought the wine to our table and honor the company with whom we enjoy it. W.B. Yeats may lament that "wine comes in at the mouth, and love comes in at the eye," and that may be "all we shall know for truth before we grow old and die." But we know better. We listen to the songs of the vineyard, birds and lawnmowers, conversations loud and quiet. The clink of glasses, like the voice of a dear friend, signals love and a longing for these experiences to last. We lift our glasses, and we sigh.

5

THE PURSUIT OF PERFECTION

From the top of Sharpe Hill in Pomfret, eastern Connecticut seems to roll away into infinity, or at least far into Massachusetts and Rhode Island. The steep slopes of the seven-hundred-foot hill are planted with grapes like chardonnay, dornfelder and vignoles, all sugarfying in the hot June sun. This unique *terroir* allows Sharpe Hill Vineyard to produce the most popular wine in New England, the award-winning Ballet of Angels. "We're not in a rush to produce just any wine," says owner Catherine Vollweiler. "We want our wine to be delicious. We want the quality." The vineyard's other wines have won hundreds of awards in national and international competitions, and in 1995 its chardonnay beat five by Robert Mondavi. We remember its 2005 fondly—a clean, round, mellow wine, with just the right amount of butter and oak.

Farther down the hill, couples lounge under shady trees, enjoying glasses of honeyed, late-harvest vignoles and chocolaty cab franc by western-style rail fence that crisscrosses the property, tasting *en plein air*. Hummingbirds zoom through the flowering margins, and sparrows dance from post to post on the trellises. Inside the enormous red barn, servers Brandie and Felicity ply us with a dry, rich st. croix. Howard Bursen, the winemaker at Sharpe Hill, bustles through on a mission. Bursen taught philosophy at Wells College in New York, made wine at home and, while writing his dissertation, took a job at Bully Hill Winery. He was hooked, and when electronics businessman A.W. Loos asked him to design a new winery in Connecticut, Bursen jumped at the chance. Built in 1981, Hamlet Hill Winery incorporated a unique circular design with an observation deck, partly buried in the earth to keep the wine production cool below.

Visitors can enjoy New England's best-selling wine, Ballet of Angels, on the terrace of Sharpe Hill Vineyards. *Photo by David Lebudzinski.*

Bursen won awards for his seyval blanc and riesling. But then, Loos sold the winery to a Frenchman who was supposed to keep the vineyard. One day, a golf course went up, and Bursen moved down the road to design Sharpe Hill for Catherine and Steven Vollweiler. In 1992, they planted the first grapevines on Sharpe Hill, expanding to twenty-five acres. He says that to grow *vinifera*, a superior site is necessary. "It's a very risky business. It's hard to make money." Luckily, the seven-hundred-foot hill at the same latitude as Rome also has six of the same minerals in the soil as Alsace. This creates a *terroir* that has produced grapes with complex characteristics.

At their first harvest in 1995, the Vollweilers' crop of vignoles formed the base for the semi-dry Ballet of Angels, along with a secret blend of nine other grapes. Catherine had long admired a painting of a child holding a bluebird and asked the New York Historical Association for permission to use it for the bottle. They later found that the eighteenth-century artist who painted it lived just down the road in Hampton. This coincidence may have been a good sign, but Ballet had not yet reached the popularity it would later achieve. In fact, over a decade passed before *Wine Spectator* gave Sharpe Hill's

2004 Chardonnay a score of ninety, the highest ever given to a New England wine. They claimed it "shows good weight on the palate kept lively by firm acidity. Pear and vanilla flavors have a touch of honey, giving a nice balance to the wine. Sleek yet rich. Drink now."

Meanwhile, on the coast in Clinton, another winery and another winemaker had already begun to take Connecticut wine to the highest level. Bill Chaney, chairman of Tiffany and Company, bought land in 1983, planting five acres of chardonnay the next year. He named the vineyard by combining the family surname with the names of his wife, Carolyn; children, Diana and Carole; and son-in-law, Matt, forming "Chamard." With a sloping site near Long Island Sound, Chaney picked the right farm. But he hit the jackpot when he hired winemaker Larry McCulloch in 1985.

McCulloch grew up in the Amish country of Ohio, earned a degree in horticulture at Ohio State and learned winemaking at the Benmarl Winery in the Hudson Valley. His knowledge of the unique challenges for northeastern viticulture gave Chamard a decisive edge. The vineyard released its first commercial vintage in 1989, and two years later the 1990 Estate Reserve Chardonnay won second place in a highly publicized blind tasting sponsored by *Cook's Illustrated*. The wine that won was priced four times as high. The judges said, "From a fledgling vineyard by the Long Island Sound, this wine demonstrates that the East Coast holds great promise for the future of chardonnay in the United States." Chamard became the first Connecticut winery to grace the pages of *Wine Spectator*.

By the time Sharpe Hill had its first harvest, Larry and Bill at Chamard were already "brave and confident," fighting off hurricanes and finches, producing six thousand cases a year. "There's nothing wrong with hard labor," McCulloch often said. Attention to what seem like small details, like hand pruning each vine or buying $700 French oak barrels, is the difference between a mediocre and a superior wine. These Burgundian-style chardonnays, with apple noses and crisp, light finishes, convinced everyone that Connecticut had achieved "superior" status. They were sold in hundreds of wine shops and restaurants, including Le Cirque and La Côte Basque.

When asked why his wines did so well, McCulloch pointed to the long, cool growing season, similar to Burgundy, and to vineyard care. "My wines at Chamard were good because I was growing good grapes." He had planted cabernet franc at Chamard in 1987 and noticed twelve years later that the tannins had started to change. The flavor structures matured and worked toward the European ideal, which happens between twenty and twenty-five years. He found that a cold-climate grape like cabernet franc actually

matures better in Connecticut than in hot climates like California, achieving more finesse and structure.

In the 1990s, Sharpe Hill developed its own cabernet franc, and by the turn of the century it had a light red with a nose of violet and plum. But what set Sharpe Hill apart from Chamard was its st. croix—earthy, almost mushroomy, adding to the same violet and plum notes of its cab franc. Today at the wine bar, the st. croix tastes like spiced roses and puts us in a fine mood for lunch at Sharpe Hill's unique restaurant, the Fireside Tavern.

We walk up a creaking staircase into the loft of the barn, confronted by hand-painted walls, rustic beams, high-backed chairs and an antique sideboard covered in silver. Vases of magenta orchids highlight a huge brick fireplace. We order the smoked trout appetizer, two fillets served warm in a mild mustard sauce with potato and asparagus in French vinaigrette. Amy samples the Jamaican jerk chicken, wood-grilled, marinated in hot and spicy

Veteran winemaker Howard Bursen likes to clown around, but he's serious about creating some of the finest wines in the state. *Courtesy of Howard Bursen.*

jerk sauce, over lemon thyme rice with grilled bananas and mango chutney. I devour the Paillard de Poulet, also wood-grilled, with a Stilton sauce, basil and tomatoes, decorated with marigolds and thyme, which we saw the chef picking in the garden earlier. To accompany this, the waiter, Robert, brings us a bottle of versatile dry riesling, which complements both the spicy jerk and the outspoken cheese sauce.

For dessert, we share the Moon Mountain Torte, layers of chocolate cake, ganache and butter cream, covered in chocolate chips, hazelnuts and white chocolate flakes and laced with chocolate liqueur. The tart riesling complements it perfectly. This restaurant was a dream of Catherine Vollweiler, who meets us after dinner on the stone patio, her Jack Russell terrier playing at her feet. "We're an academic winery," she tells us, with a full vineyard, thirty-person staff and, of course, a veteran winemaker. She makes it clear that to get rated in *Wine Spectator* or be featured in almost a thousand wine shops, you must do everything properly. But of course, the rating is not the final goal. "Whatever you do, you have to do graciously."

Catherine takes us into the antique red barn, and we are confronted with enormous fermentation vats, two stories high, with metal maintenance catwalks. They are the equal of many we'd seen in California, and we realize we might be seeing the hope for Connecticut wine manifested right here. Catherine shows us the long barrel room kept the proper temperature by a bank of computerized switches. "If anything goes wrong, alarms go off." Literally. Showing us the quality barrels, she says firmly, "If you make wine and want to compete with the world, you have to invest in great cooperage, and in the technology."

The Vollweilers of Sharpe Hill have inspired others around the state. Traveling from Pomfret through the famous Lebanon Green into Colchester brings us to Priam Vineyards. People pull up the gravel drive and sit on the porch around gleaming wine glasses. Butterflies land on the wet, yellow flowers. Miles Davis's *Sketches of Spain* filters onto the porch, and bluebirds flit through the margins of the yard, managing the insect population. Gary Crump greets us in his New Orleans twang. He had worked from 7:00 a.m. to 3:00 p.m., changed clothes, tractored the driveway and greeted guests, holding a glass of white wine.

Gary moved to Connecticut in the 1980s, meeting Gloria Priam in 1988 in Norwalk. They married six years later and decided to pursue their shared dream of owning a farm. At first, they decided to grow Christmas trees but then settled on grapes after some encouragement from their friends, the Vollweilers. Gary and Gloria started growing grapes on the farm in

Colchester, originally to sell. But like so many others who started that way, Gary and Gloria were not satisfied. The winery began operating in 2002, opening in 2003.

They named the farm after Gloria's grandfather, Andrew Priam, who made wine in Hungary, where he was born in 1922. He was driven out when the Russians took over. Amazingly, Gloria did not learn that he worked a vineyard in Budapest until after she decided to plant the vineyard in Connecticut. The vineyard that Andrew Priam planted still grows in Hungary, and Gloria's dream is to go there, get a cutting from those vines and bring it to Connecticut.

A few hours before we visited Priam, a group of German vintners toured the tasting room, leaving with an entire case of riesling. Gloria says that the soil and climate are identical to the Alsace region of France. "These guys know Alsatian wines. That's what we grow," confirms Gary. He talks about the second generation of winemakers beginning with Chamard, which focused on Burgundy-style wines, where "we really began to see what would work in this climate and area."

In 2006, Priam expanded, buying more acreage and adding to the winery, including the patio we are now sitting on. They have a farmer's market at the vineyard every Friday in the summer and fall. Solar panels are going up next week, and Gary tells us, "We'll be completely green after that." This attitude has left a very beneficial environment, with fat, healthy toads and rare turtles. The National Wildlife Federation has even certified the forty-acre farm as a natural bird and wildlife habitat.

Gloria shepherds us into the tasting room, where we gather around the counter with dozens of other guests. She and Gary pour the wine with some help from the waiters. Named for the local watershed, Salmon River White is a citrusy mix of chardonnay, riesling and muscat. This was the first wine Gary made as a commercial winemaker, for which he immediately won international gold. Someone asks how they find the best blends. Do they have a winemaker like Chamard or Sharpe Hill? "My wife and I sit on the porch of the house with a pen and notepad and we taste." Gary Crump laughs.

Despite their modesty, Gary and Gloria know that their wine needs to appeal to critics and consumers alike. "You have to develop a market," says Gary. Apparently it is working. A couple nearby buys an entire case of wine, mostly the gewürztraminer, of which there are only a few bottles left. Other guests discuss the merits of the dark and lovely Salmon River Red, a blend similar to a Bordeaux. But the smoky, berry flavors seem different, unique to

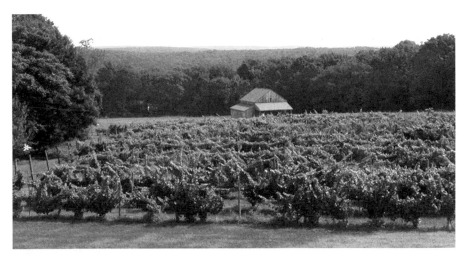

With panels installed in 2010, Priam Vineyard is the state's first solar-powered winery. *Courtesy of Priam Vineyards.*

this climate and even to this winery. Gary agrees, saying that local produce "shouldn't taste like it comes from California. It comes from Connecticut."

Since the day years ago when the Vollweilers urged them to grow grapes, the two couples have remained friends. Recently, they ate together at the Fireside Tavern, and Gary and Gloria brought the wine, including a 1959 Tokaji, the sweet Hungarian wine of legend. Gary shows us the empty bottle, recalling the scent of eucalyptus and the sweet orange taste. He points out the handcrafted work that went into the Tokaji and says, "If you don't care about the bottle, you probably don't care about the wine. They care about what they produce. This sums up our philosophy."

Back at Sharpe Hill, Catherine echoes Gary's words. "Number one," she says, "know great wine." She takes us to meet her husband, Steven, just off a hard day's work. In the old barrel room they outgrew and furnished, he talks to us about his vision over glasses of their famous chardonnay and Ballet of Angels. "We all started and had to prove ourselves," he says, telling the story of how he began making four hundred bottles in their basement. "I wanted to make wine I would drink." And now, they harvest unusual grapes like melon de bourgogne and carmine. Riesling, dornfelder, gamay and landot noir also spread across the slopes. They are even applying for their own appellation. "We're the real McCoy," Catherine says proudly.

As the last customers of the day leave, their daughter, Jill, leaves the front desk and joins us. She is a marathon runner and seems ready to take over the

winery some day. She'll need the endurance if Sharpe Hill wants to continue to lead the pack. By 2010, Connecticut wineries were winning competitions across the world, and others seemed ready to challenge Sharpe Hill. But they would forever be indebted to the brave vintners before them whose ingenuity and hard work have spurred them to pursue richer depths and more spectacular complexities. Sitting in that old barrel room, sipping some of the best wine we've tasted, we had the remarkable illusion that we could feel that pursuit and suddenly knew the secret of this Connecticut wine's success. We could taste the future.

6

GET TO KNOW YOUR
CONNECTICUT GRAPES

When Pilgrims landed in New England in 1621 they reported, "Here are Grapes white and red, and very sweete and strong." Later, the colonists started to cultivate grapes for winemaking, hoping to become less dependent on French claret. As many as fifteen species may have dotted the landscape of the Northeast, with varieties numbering in the hundreds for both "pure" and hybrids. Successes varied, and they found the American *labrusca* grapes too sweet for their preferred style of wine. As early as 1800, attempts at hybridization of European and American grapes took place. Writing for Congress in 1862, James S. Lippincott recognized that viticulture in America was a marriage of native and foreign species. "The recent introduction of numerous varieties of native American grapes and the creation of several hybrids between the indigenous, hardy species of our woods and the best foreign kinds have afresh excited an interest in grape culture in the United States."

Grapes around the world share the genus designation *Vitis*, with European species specified as *Vitis vinifera*. Latinate terminology for species in North America offers additional mouthfuls like *Vitis riparia*, *Vitis aestivalis* and *Vitis labrusca*, which is the most widespread. Common names suggest a little more playfulness: fox, pigeon, chicken, frost, summer and winter grapes, just to name a few. As varieties developed, grape identification became more personalized. After considering thousands of fox grape seedlings, Ephriam Walks Bull developed what he considered "the perfect grape" in 1849, and he named it for his hometown of Concord, Massachusetts.

In the mid-1800s, the isabella grape grew well in southern Connecticut near the coast. The catawba grape and its "daughter," diana, came in twenty years after. A grape called the sage was developed in Portland, Connecticut, and the catharine was grown in Hartford. Exhibiting new grape varieties began to be a point of pride for farmers in the late 1800s, and no doubt part of that was coming up with names as intriguing as the brighton, the dracut, ambeil, the northern muscadine, rebecca, martha, goethe and prentiss. At Mr. and Mrs. David Deforest's vineyard, a new species "of the purple kind" was found in 1824, named the lafayette for the famous Revolutionary War general who so recently had returned to Connecticut.

In the 1860s, John Dickerman had no problems with frost on the southern slope of the Sleeping Giant and experimented with various grapes, trying American species like catawba, isabella, hartford prolific and delaware, which required "the very best conditions." The clinton grapes were "questionable" for wine production, and the catawba and isabella needed added sugar. But Dickerman also planted German grapes like riesling, which he found he had to cover during the winter and were more susceptible to mildew and rot. Nevertheless, by 1871 the yield of the vineyard was almost seven hundred gallons of wine per acre.

Agriculture has always depended on farmers selecting and propagating the best plants, and cross-pollination is a simple fact of nature. Grapes are mainly cultivated with cuttings instead of seeds, so the sturdiest vines could easily be divided and grown as many new ones. In fact, this is still how new vines develop today. Hybrids, of course, occur naturally and simply mean crossing two species of plants, and grapes have always been "customized" to better suit winemaking. In wine-speak, there are distinctions between crosses and hybrids. Cabernet sauvignon, for example, is a cross between two *Vitis vinifera* grapes—cabernet franc and sauvignon blanc—resulting in another *Vitis vinifera*. Hybrids, by contrast, occur when two different species of plants are crossed, most notably when *vinifera* and American *labrusca* cross, resulting in the blanket term "French-American hybrids." Anyone remembering tenth-grade biology knows hybrids typically have stronger characteristics, though in some minds, European grapes are the gold standard.

Much of the more recent success in Connecticut and other states not known for wine grape production is due to the innovative work of Dr. Konstantin Frank and Cornell University in the Finger Lakes. As late as 1950, when V.P. Hedrick wrote *A History of Horticulture in America*, it was thought that "the European grape cannot be produced successfully in eastern America." Dr. Frank and others like him proved that to be false.

Hedrick made the assumption based on two problems. First, the phylloxera outbreak of the late nineteenth century, which had already been solved by grafting *vinifera* on American rootstock, an innovation that saved the European wine industry. The remaining issue is the molds and fungi that attack the grapes in this wetter climate, a problem that has been solved more recently by improved fungicides.

Dr. Frank had grown *vinifera* in his native Ukraine and knew that European species could grow in colder climates. Grafting these varieties to American rootstock, he was able to grow whites like chardonnay, riesling and gewürztraminer and reds including pinot noir and cabernet sauvignon. New York State's Agricultural Experiment Station in Geneva, as part of Cornell's Agriculture College, has pioneered the development of French-American hybrids like cayuga white, one of the grapes that does quite well in Connecticut. Likewise, the University of Minnesota has worked to develop cold-hardy hybrids.

Closer to home, the oldest agricultural experiment station in the United States is based right here in New Haven. With farms around the state, the Connecticut Agricultural Experiment Station continues to study soil attributes, vine performance and fruit quality, along with pruning methods and pest and fungus reduction practices. Here, Dr. Richard Kiyomoto established himself as an authority on growing grapes that do well regionally. "He [has] pushed the growers to have a higher-quality fruit," says Gary Crump. Kiyomoto grew up at a vineyard in California, earned a PhD in plant pathology from Washington State University and came to Connecticut in 1982. He retired in 2002 but continues to advise growers and perform grape research at the University of Connecticut. Expertise like this has helped owners take the guess work out of choosing grape varieties, and it is no coincidence that his tenure has coincided with the rise of Connecticut's wine industry. Bob and Carol Chipkin of Cassidy Hill Vineyard sought his advice and gained his friendship. "We were very much in his debt early on," said Bob, citing Kiyomoto's tireless work to help them figure out varieties and plantings.

A complex array of factors contributes to the success of grape growing and therefore winemaking. The French were the first to recognize this collective environmental influence, using the term *terroir* to denote the land's influence on grapes. Along the coast of Connecticut, the soil seems to impart more mineral-earth to the wines, whereas the highlands provide more of a loamy characteristic. But in all areas, wine tasters are likely to detect notes that result from the rocky soil, which becomes "part of the mineral quality of our wine," says Mike McAndrew, winemaker at Stonington Vineyards.

One measurable factor is the number of Growing Degree Days (GDD), which are calculated based on a formula that assesses the total amount of heat the plants absorb from April to October. Measuring GDD, we find that the wineries of Gouveia in Wallingford, Jones in Shelton and Priam in Colchester have the warmest sites, with about 1800 GDD. Wineries in Litchfield County and along the shore have approximately 1600. Connecticut therefore is in the same range as the coolest regions of France and the Rhine region of Germany and actually has a hotter climate than most of Burgundy.

This alone cannot indicate whether grapes will do well here but demonstrates that challenges can be overcome. Howard Bursen, winemaker at Sharpe Hill, notes that the most esteemed wines in France come from areas with a similar climate to Connecticut, not California. Indeed, "wine that has to survive Connecticut's summer and winter gets unique flavors," says local celebrity Colin McEnroe. "There is something about that narrow margin of time and climate…it does produce a special kind of wine, a wine that has to live through that."

One Connecticut-grown *vinifera* grape familiar to everyone is chardonnay. Likely to be a cross between a "nearly extinct variety called *gouais blanc* with a member of the 'pinot' family," chardonnay is like a "blank canvas," greatly affected by soil and the chosen style of the winemaker. Malolactic fermentation and oak barreling create butter notes, while steel fermentation provides green apple notes. Wineries like Stonington offer both options, and we found Sheer Chardonnay smooth and crisp and naturally buttery without the "over-oaked" effect that is often found in Australian versions.

First developed in Germany in the fifteenth century, riesling has also found a place in Connecticut's vineyards. Gloria Priam remarks that "the soil and climate, particularly along the coastline, is the same as the Alsatian region [of France]," where riesling thrives. Tolerant of cold, riesling can be dry, semisweet or even dessert. Another favorite of Alsace, pinot gris, also does well in Connecticut. Called pinot grigio in Italy and California, Connecticut's pinot gris is high acid, making it a great wine with food. Jonathan Edwards's Estate Connecticut Pinot Gris is great with a New England clam chowder. Other European whites like gewürztraminer can be cultivated, and we find Priam's version crisp with hints of spice.

Vinifera reds are more difficult to harvest in large quantities, though wineries across the state grow them. But it is a challenge to foster the full-bodied reds, like merlot and cabernet sauvignon, that might be found in warmer climates. Gary Crump acknowledges that lower yields may be the only way to ensure

quality. Of pinot noir, which is notoriously temperamental, James Baker from Hopkins says, "We can't do justice to it in our growing conditions." Of course, that doesn't stop winemakers from trying to grow it here, though most use it for blends.

One of the best bets for a *vinifera* red is cabernet franc, which has thinner skin than its offspring cabernet sauvignon, ripens early and is much better suited to withstand cold winters. Traditionally, it is a blending grape in Europe "because of the harshness, the herbaciousness, the greenness of it," says James Baker. But in Connecticut's soil, these potentially severe characteristics become more rounded, and the resulting wine fills with vanilla and spice. James says, "Let California grow cab sauvignon" because it is actually a much softer wine, a "showgirl," whereas cab franc is "the brawny boy."

Other *vinifera* options include lemberger and dornfelder. As winemakers are always on the lookout for grapes that ripen earlier, these are good options; they grow well in climates that mirror our own. Lemberger, first cultivated in Austria, Hungary and Germany's Wurtenberg region, is now

Developed in Germany, dornfelder is an up-and-coming grape, proving that lesser-known varieties, suited to colder climates, are smart choices. *Courtesy of the authors.*

being developed with success by Hopkins. The cold-hardy grapes become dark blue upon ripening and have tannins that are similar to those of merlot. Notes of black pepper come out in blends like Hopkins's Red Barn Red and Sunset Meadows' Twisted Red. Dornfelder, also developed in Germany, has the potential for high yields and has a strong resistance to rot, and the wines produced from it have the potential for higher alcohol content.

Vinifera may still be more recognizable, but French-American hybrids may actually be a better bet for Connecticut's climate. Experimentation has always been part of growing grapes in Connecticut. In 1872, T.S. Gold, secretary of the State Board of Agriculture, spoke specifically about grapes when he said, "Special crops, adapted to special localities, present the best examples of success in Connecticut." In the hands of Connecticut's great winemakers, these "specialized" species are not only proving to be well suited to the Northeast but are also changing minds and developing into the best wines in the state.

To answer the contention that reds cannot grow in climates like that of Connecticut, Dr. Richard Kiyomoto suggested st. croix as a cleaner grape with more yield. Developed by Wisconsin native Elmer Swenson, st. croix is good for short growing seasons, as it can survive harsh cold and is disease resistant. Wineries across the state have seen exceptional results with this small but intense fruit. At Maugle Sierra, it surprises with notes of blueberry on the nose. For Sunset Meadows' version, caramel, blackberry and pepper combine for beautiful complexity.

A Minnesota transplant, frontenac is a cross between landot, another French-American hybrid, and native American *Vitis ripara*, commonly known as the frost grape. As such, it does well in cold weather, has been developed to be resistant to disease and mildew and usually produces a low-acid wine. Dark garnet in color, wines made from frontenac impart lots of ripe berry on the nose and dried cranberry notes in the middle. Connecticut Valley Winery allows it to go through malolactic fermentation and ages it in French oak to give it a lovely mocha finish.

Marechal foch, named for French hero Ferdinand Foch, was hybridized in France and grows well in the Loire Valley. Jerràm's Western Connecticut Highlands version is deep violet with a hint of ink. Dry yet smooth, its bite comes from notes of dried fruit, like cranberries or raisins. Haight-Brown blends foch for Morning Harvest. We liked the earthy complexity and chocolate finish so much that we gave bottles as favors at our wedding. Other hybrid reds that show promise are marquette, baco noir, corot noir, carmine and chambourcin, a cold-hardy, disease-resistant grape that Priam has used in its Westchester Red.

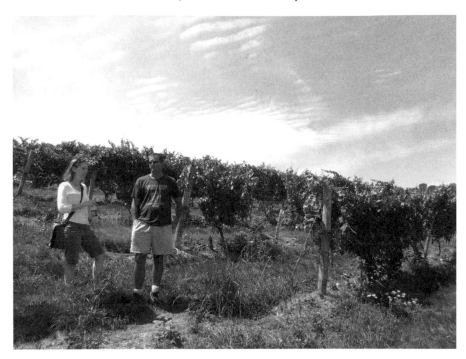

Hopkins winemaker James Baker's favorite part of his job is spending time in the beautiful vineyard. *Courtesy of the authors.*

Researchers seek to exploit the hardiness of the native grapes to produce better winemaking capability. That philosophy spurred hybridized grapes like cayuga white, one of Connecticut's strongest. Developed in the 1950s by Cornell, this grape is a cross between schuyler and seyval blanc. Gary Crump says it is an "all-around winner," and Priam's version is nearly clear in color, has a pear nose and offers little tartness and hints of vanilla. With high yields and the option for many styles, Gary says, "If I could plant only one white grape, this would be it." Cayuga's parent, seyval blanc, also does well. At Miranda Vineyards, it has green pepper on the nose and a tart mix of green apple and honey in the middle.

Since German grapes have already proved themselves in Connecticut, it is easy to see why traminette does well. Developer H.C. Barret crossed gewürztraminer with another grape and sent the seeds to Cornell, where they were planted in 1968, creating a versatile grape. It can be fermented dry, like North Wind's version, or lightly sweet, like Taylor Brooke's adaptation. The floral notes that come on the nose are distinct and inviting.

Hybrids also offer a variety of winemaking options. Vidal blanc's citrus notes and high acid, which are found in Stonington's bottles, make a wonderful wine, easy to pair with food. But it makes a great ice wine as well, left on the vine and harvested when the grapes are still frozen. Winter harvesters brave the cold and snow at Hopkins to pick the tawny bunches. Similar qualities make vignoles a good choice for dessert wine. These grapes range from green to near pink on the vine, and Sharpe Hill and Northwinds Vineyards allow the effects of botrytis, or noble rot, to intensify the sugars and develop burnt honey–flavored dessert wines.

The list is potentially endless—from villard blanc and pinot blanc to chardonel and chelois. As hybrids prove themselves across the state, we are likely to see names like melody, la crescent and frontenac gris climb into the ranks as choices. Even as vineyards continue to experiment with the grapes, winemakers wonder if Connecticut will settle on a few that thrive, like st. croix; take on unique qualities, like cabernet franc; or showcase the characteristics of our soil, like riesling and chardonnay. That may be something the industry could determine, but for now there is much to marvel at in Connecticut's long catalogue of diverse grapes and its equally long list of exceptional wines.

7

FARMING FOR A LIVING

I f our family wanted to make money, we would have sold the farm for
houses years ago," says Jamie Jones, driving up Pumpkinseed Hill. The
Jones family purchased this one-hundred-acre section of their four-hundred-
acre farm in the 1980s, outbidding a subdivision developer. Jamie explains
that thanks to the great Development Rights Program, they were able to
sell the mortgage difference to the state and pay taxes at the agricultural
rate, guaranteeing that the land stays a farm. "Crops don't need that many
police officers or to be sent to school." He laughs and then turns serious.
"It's the only way to pass land on to the next generation." Jamie is the sixth
generation of his family to farm the land in Shelton and the driving force
behind the Jones Farm Winery.

People don't associate vineyard wineries with farming, but of course that
is exactly what they are. "It's a farm first and foremost," Jamie says. On
the southwest slope, we drive through fields of strawberries and pumpkins
to a block of vidal blanc. Also on these hills are cabernet franc, merlot,
chambourcin, muscat, traminette, chardonel, cayuga and lemberger. Jamie
gets out of the truck and rips off some rootstock that was climbing up one
vine. "I'm fortunate. We have a good site. I paid attention in class." Across
the lane is pinot gris, which "grows well in Connecticut." Even in the very
wet year of 2009, 90 percent of the gris ripened, and Jamie is really excited
about that. "Why grow cabernet if California can do it better? Why grow
chardonnay if everyone else around is growing it?"

Jamie's ancestor, Philip James Jones, an immigrant of Welsh-Irish descent,
bought land in the White Hills of Shelton in the 1850s. He raised cattle,

chickens and sheep and grew potatoes. His son and grandson transitioned to a dairy farm, calling it Broad Acres, and in the twentieth century, Philip and Elizabeth Jones transformed the farm again, creating one of the first Christmas tree farms in the country. The fifth generation, Will, Terry and his wife, Jean, planted fruit for pick-your-own. Now, six generations removed from that immigrant ancestor, Jamie and his wife, Christiana, have added their own stamp with these grapes. Of course, such a diversified farm presents its own challenges. "I want to plant more grapes, but the next field I want to plant in is full of Christmas trees that won't be cut for two years," Jamie says ruefully.

Jamie graduated from Cornell University's agricultural program in 1998, and his exposure to the Finger Lakes wine country inspired him. The family was very supportive, giving him acreage to experiment, which kept expanding as the business became profitable. He planted both *vinifera* and hybrids, because "I kind of want to hedge my bets." They did not have a tasting room, but "we had thousands of people already coming to the farm to pick." Now, eleven years after planting, the winery accounts for about 25

The sixth generation of his family to work the land, Jamie Jones planted grapes and became president of the Connecticut Wine Trail. *Courtesy of the authors.*

percent of the entire business and keeps growing. Of course, they already had suitable land, so they bypassed the largest expense for hopeful vintners. At over five hundred feet high and only twelve miles from the sea, they get a huge number of "heating days." And because the soil has a rich history, "that's why the grapes have done well."

When picking up a bottle at the store, it's easy to forget that winemaking begins with farming, which means hard work. At Jones, weeding, mulching, mowing and more are done by hand. They try to reduce the number of farm chemicals, enrich the soil with natural compost and use no-till farming for some crops. From composting woodchips to spraying fungicides, there is always work to be done. On top of that, a successful farmer needs expertise in human resources, marketing and lobbying. Winemaking can be profitable, but it adds yet another layer of work after harvest. "There's always so much going on," Jamie says, pointing out that a choice like starting a winery could sink a farm or renew it. Now, with the wine industry growing exponentially, it's a choice that more and more farmers in Connecticut will be struggling with.

The transformation of state agriculture is nothing new. As soon as settlers found the rich soils of the Connecticut River Valley, they moved there, growing new crops like corn, squash and potatoes. In time, peaches, poultry and tobacco have all led the state's crops. Grapes have never come close to statewide importance, except for a few years right before Prohibition. Of course, most colonial farmers did not bother growing grapes because they grew wild nearby. Besides, there were other, more important crops to sell at market. Today, however, grapes are the fastest-growing crop in the state. Farms raise what the customers are looking for, and increasingly they demand wine.

Hopkins was the first of the old family farms to turn to grapes; Hilary Hopkins Criollo points out that many envision grape growing as a hobby or retirement project. "It's romanticized," says Hilary. "Until you actually have to do the work." But farmers like Keith Bishop, the fifth generation of his family to farm in Connecticut, have no such illusions. He has also turned to winemaking, with a full selection of fruit wines and grapes now planted on his three hundred acres in Guilford and Northford. Like Jones, Bishop's Orchards was one of the few family farms to continue making money, mostly because of direct sales. It pioneered the use of the farm market, starting with a roadside stand in the early twentieth century and building a hugely popular store along the Post Road. Nevertheless, the 136-year-old business has seen the way the winds are blowing in the twenty-first century, and wine takes its place alongside their bakery, pick-your-own fruit and llamas.

At the north end of the state in Simsbury, down the road from the mighty Pinchot Sycamore, another farm has found hope in wine. Rosedale Farm was founded early in the twentieth century by Morris Epstein, whose slogan was: "You can whip our butter, but you can't beat our milk!" The tradition continued with his son, Louis, and his grandson, Marshal, who took over in 1983. In the early 1990s, Marshal and his wife, Lynn, had a discussion with their neighbor, Charlie Stephenson, who already owned a small vineyard down the road. The Epsteins started their winery, and by 2005 their wines featured a variety of hybrid grapes from nearby New York and the farm itself. Made from cayuga grapes, Three Sisters has a dry, Alsatian-style fruitiness, while Sundance uses a sweeter mix of niagara and seyval grapes. Today, the Epsteins say that their diversification is key to their success.

Farther west, beyond the historic Beckley Furnace in East Canaan, the Adam family owns one of the few nationally recognized bicentennial farms in the state. Now in its ninth generation, the two-hundred-acre farm planted grapes in 1994, producing its first Land of Nod wine four years later. Named for a poem by Robert Louis Stevenson, Land of Nod grows blueberries and raspberries and runs a popular sugarhouse where visitors can create maple syrup, "Mother Nature's pure sugar." By diversifying with grapes, 230-year-old Land of Nod has become more popular and perhaps saved its farm for the tenth generation.

But that's not all. Winemaker William P. Adam has pioneered two fascinating grapes, which may turn out to be Connecticut staples. Bianca, a Hungarian grape, creates a wine that tastes of pear and cloves. And their corot noir has a unique mix of black currant and anise flavors. Both of these hardy grapes survive our cold winters easily. By forging their own path, Land of Nod may do more than just survive; it may help others find a way.

Jones Farm has long experience providing models for agricultural success. Jamie drives us to another hill, the Homestead Farm, planted with dozens of acres of Christmas trees: blue spruce, angel pine and Fraser, balsam and Douglas fir. His grandfather planted these trees in the 1930s and '40s, originally to reforest some of the land. Then a neighbor asked to cut one for his Christmas tree, and a new business was born. Soon, the Jones family helped found the National Christmas Tree Growers' Association in 1960, and these "tree farms" became American icons.

A rabbit runs across the road as we pass a pond that Jamie's grandfather dug to give his new wife running water at their house. His parents' house peeks out from the mist-shrouded trees. Higher and higher, we pass the

site where the original Philip Jones built his farmhouse in a landscape that reminded him of the British Isles. On a clearer day, you can see the blue shimmer of Long Island Sound from the top of this hill, two miles from the vineyards. That is one reason why the military chose this as a Nike missile and radar site, taking twelve acres of land from Jones in the 1950s. The military built this outpost to prepare for a possible Soviet attack, but its constant helicopter flights made the cows nervous and killed milk production. "It was a sad time in our family when the government took over [that] land," says Jamie.

Today, in another fantastic reversal, the mess hall for the permanent company of soldiers has been transformed into the Jones winery. Inside the building is winemaker Larry McCulloch, formerly of Chamard, cleaning the filters. Accompanied by a brown dog named Cooper, he stands in calf-high black rubber boots, a lime green polo shirt and khaki shorts with a bandana hanging out of a pocket. Nearby is a brand-new bottling machine, and the decision to invest in this $50,000 piece of machinery and in a veteran winemaker like Larry means a decision to stay in the wine business.

Larry is frustrated by other vineyards that aren't doing it "all the way" and capturing what is local and unique about their farms. He calls himself a wine grower rather than a winemaker. His job is to "get out of the way and let the grapes speak. I'm not doing anything magical." Jamie is already an expert in agriculture, but Larry has changed a few methods. He cuts the fruit and pulls leaves, lowering the yield but increasing quality. To compensate for the apparent loss, Larry added a second fruiting vine to increase yield, giving each cluster its own growing region on the vine. He lowered temperatures in the fermenting vats, slowing the fermentation down to increase the notes. This constant attention to quality control matters because "every day is different." Today is a Friday, and as we leave, Larry grins. "There's only two more days in the workweek," he says.

On another hazy day on Route 12 between Mohegan Sun and Foxwoods Casinos, we stop at the red market of Holmberg Orchards. Inside we find fresh asparagus, Brussels sprouts, red tomatoes, blueberries and squash under displays of the farm's artifacts: barrels, coffeepots, an old rolling pin, torn clippings of recipes, a pitchfork, a plane and a yoke. This family farm in Gales Ferry is in its fourth generation, founded by Adolph and Hulda Holmberg from Sweden in 1896. In 1935, Harold and Henry Holmberg added fruit trees to the vegetable farm, and they became known for their quality apples. Now, they are diversifying further. Through the recent Farm Wine Act, everyone can sell other vineyards' wines, and today Holmberg

Art in the orchard. Holmberg selects a pear at blossom and grows it in the bottle for Westford Hill Distillery's signature Pear William eau-de-vie. *Courtesy of the authors.*

features samples from Sharpe Hill, Chamard, Stonington, Taylor Brooke, Jonathan Edwards and Maugle Sierra. Next to these are Holmberg's own ciders and fruit wines.

Above the market, the 250-foot hill rises steeply from an imposing barn, providing an optimal spot for orchards and now vines. We are here to meet Russell Holmberg, whom Linda Auger from Taylor Brooke calls, with his sister Amy, "the new generation." Like his father, Richard, Russell graduated from the University of Connecticut's agriculture program. When he returned, he started a cider and fruit wine operation. Amy runs the retail management side of the business.

We meet outside the oldest building on the farm, an 1850 shed used at times as a horse stall, fertilizer storage and a cider manufactory. Now restored to rustic perfection, it serves as their tasting room. Curly hair blowing in the wind, Russell walks eagerly up the steep hill with us, pointing out varieties of apples. "We're a farm where we grow fruit, and we've been doing it a long time," he says. "Everything you see here goes out our front door." Below, the Mohegan Sun Hotel towers above the Thames River Valley. Only eight

miles from the Sound and 250 feet above sea level, they have a coastal climate, "one of the best places in the state to grow fruit."

At the top of the hill, we see the new rows of vines. Many of the recommendations were for hybrids, but the great winemakers like Larry McCulloch and Mike McAndrew from Stonington told them that the site was perfect for growing *vinifera*. So they planted pinot blanc, a less buttery cousin to chardonnay, which had been planted at the old Crosswoods Winery back in the 1980s by mistake. Russell says it has more "oomph" than pinot gris. The only problem was excess groundwater, so they used tiling like many sites in northern France and now have "happy grapes with dry feet." In a couple years, Russell's "contribution to the project" will be ready. However, he won't stop there; plans are to plant the acreage all the way to the fence line.

Investing in state-of-the-art machinery like mechanized bottling machines allows wineries like Jones Family Farms to consistently produce quality wines. *Photo by Jeremy Pollack.*

Russell has a ways to go to catch up with his friend Jamie. Back at Jones's Valley Farm, we pass the fields where we've picked our own strawberries many times. In a collection of houses and barns, we walk into the tasting room that once was the cellar of an 1870 cowshed. "When I grew up, this was filled with hay," says Jamie. The beautiful white pine slabs that serve as the bar were milled from trees planted by grandfather Philip Jones in the 1930s. Earlier, Philip himself had stopped in the tasting room to grab some chocolate and say hello.

We've been to Jones often to taste and have always been pleased with their wines. But we have to admit to Jamie that Larry's presence has taken the reds to the next level. Their succulent cabernet franc has more clove than Hopkins's version but otherwise retains the distinctive Connecticut vanilla. The garnet-colored Ripton Red is balanced and rich. Jamie is estate bottling "Vintners' Selections" and thinking about turning the barn upstairs into wine-by-the-glass seating—to "keep things interesting coming down the pike."

Jamie's wife, Christiana, meets us in the tasting room. They live in Jamie's great-great-grandparents' house, and her "off-farm" job is at the nearby Osborne Homestead in Derby, so it is no surprise that she tells us how important the sense of history is. "We have a heavy dose of reality here." She is pregnant with their third child, a daughter, and tells us how fulfilling it is to bring up a family in this environment. Her two sons show enthusiasm for the farm, and we can see why, with generations working together, tied to the land. "Be good to the land, and the land will be good to you," said founder Philip James Jones in the 1800s. No doubt, the Jones family will continue to find ways to be good to the land. Will winemaking continue to be a part of that equation? That's a multifactorial, complex decision, a balancing act of survival and tradition, of happiness and hard work. "I like to think of myself as a simple farmer," says Jamie, but it is never that simple.

THE SCIENCE AND ART OF MAKING CONNECTICUT WINE

Perhaps the many paradoxes associated with wine are what make it so intriguing. To some, it seems to be simple—a liquid derived from fruit changed by the natural processes—yet the complexity of its development perplexes even the most imaginative of dreamers. The events that bring wine to the glass are basic to biology and chemistry, yet somehow we think it is magic that enchants our senses. Winemaking itself is effortless and demanding, time-consuming and seemingly instantaneous, rewarding and backbreaking, hobby and livelihood.

Though it takes many hands and definite manipulation, much is left to circumstance and nature. Dr. Paul DiGrazia explains, "Winemaking is sensory data rather than math and chemistry. We leave what's natural on grapes, white stuff—yeasts and fungi. This improves glycerol content and gives a wine legs and mouth feel." Connecticut's winemakers employ traditional methods and the latest in science and technology, continuing to improve the approach and the results. That these methods change tiny orbs of fruit into such a diversity of styles, pairings and possibilities seems to be among the most artistic phenomena. Indeed, as Steven Vollweiler of Sharpe Hill Winery asserts, "Making good wine is science; making great wine is art."

As new wineries open and vineyards sprout, the public enterprise of oenology spreads. However, wine production continues to be a private affair as it has for centuries, made by anyone with access to fruit on hand. In the days of the early colonists, women took the jobs of brewers and distillers, making wine, brandy and cordials in their pantries and root cellars. Men helped out with the pressing and, of course, the drinking. Even children were

Both scientist and artist, Larry McCulloch earned his reputation at the Chamard winery before joining Jones. *Photo by Jeremy Pollack.*

put to work gathering fruit. All participated in the transformation of simple grapes into a pleasing beverage to be savored in the parlor, the kitchen or on the back porch.

Today, homemade winemakers thrive across the state. Jason Venditto of Hamden got into winemaking with his wife Pia's Italian family. "We do everything by hand," from crushing and pressing to clarifying and bottling. Grapes can be purchased wholesale and picked up like any other commodity, vat by vat, or they can be acquired from retailers such as M&M Wine Grape Company in Hartford, Conchia and Sons in Norwalk or Maltose Express located in Monroe. Grapes are usually those for traditional blends, including sangiovese, merlot and alicante, an intense red grape used mostly for color,

Jason says. Pressing is done at cousin Anthony Cusano's garage in New Haven. After about a month and a half, the juice is ready to be bottled and drunk. With the output comes a sense of pride, and "it's a lot of fun."

Jason brings an unlabeled bottle to a Sunday gathering of friends. All agree: it is decent stuff, more than decent, actually. It is pretty good. The sangiovese is dark in color, fruity like a merlot on the nose with a light cherry taste. They have not added yeast but let the natural elements of the grapes work alone. Though the wine does not have a lot of finesse, with its light tannins, it is easy drinking, smooth and a very nice companion to cheesecake. A bottle of wine at the dinner table has been a staple of family life for generations. Jason appreciates that he can contribute to that tradition of sharing with loved ones. "I want it to taste good and I want others to feel good afterward."

Today, home vintners vary from casual participants to fierce competitors, from those who adhere to the principle that grapes' natural characteristics should not be tampered with to those who tinker like chemists in lab coats, adjusting balance between acid and sugar. Many recreational winemakers like the Vendittos build on their immigrant experience, relying on family recipes and childhood memories of making wine in places like the Azores, Portugal and Greece. And there are no shortages of outlets for these winemakers to share their results. Occasionally, some friendly competition can sweeten the taste. Home vintners gather at places like Reis and Son Import and Export in Bridgeport or during the Italian American Festival in Southington. They seek advice from other amateurs like author Gene Spaziana, whose book *The Home Winemaker's Companion* is often the go-to text for those looking to start or improve techniques. In a sense, it may be incorrect to call such enthusiasts amateurs, since methods become more and more precise as science and expertise play greater and greater roles.

For the less ambitious, help is available. Companies like the Wine Press run by Frank Martone and Ray Iannucci in North Haven do most of the work, allowing people to choose single-variety wines, like riesling or chardonnay, or blends that might include zinfandel or little-known carmenere, a red grape imported from Chile. Creativity is encouraged; one could bring together up to five types for a meritage option or perhaps a Bordeaux-style wine. While guidance and oversight is provided, the Wine Press invites patrons to participate in every stage of the winemaking process. The end result is still magic—personalized bottles ready to share.

Another option is a classroom atmosphere. Dalice Elizabeth Winery, for example, offers winemaking classes at its wine school. Here, too, from

crushing to bottling, every stage of production is taught in a hands-on environment. Whether hobbyists or serious students with intentions to move on to bigger realms of wine production, participants in classes such as these change curiosity into skill. With a background in specialty food production and a long list of awards, owners John and Mary-Lee keep the family traditions alive, and their desire for excellence is passed on to students at the wine school.

Vineyards like Chamard offer another possibility for groups of amateur winemakers with a "custom crush" program. As the winery owners have secured plots in premium areas for each type of grape, customers are able to choose which variety, and even which region the grapes will arrive from: Northern California, New York state or from Chamard itself. Once selections are made, grapes are transported to Chamard for processing. The next decision is preference of style and barrel selection. Pressing, crushing and fermenting are done on site by practiced winemakers. Finishing the process with personalized bottling and labeling, this is perhaps a little less hands-on than the do-it-yourself garage option. Nevertheless, opportunities for those at any level of experience or commitment are available.

Despite the occasional acre of vines in someone's backyard, home winemaking relies mostly on imported grapes. Connecticut's commercial winemaking industry, however, must be more concerned with quality control, consistency and promoting local, sustainable agriculture, as well as a beautiful product. From hand harvesting to investing in state-of-the art machinery, winemakers at the highest level have more resources but have to worry about yields as well as profits.

Whatever happens in the bottle, winemakers across the state agree: it begins in the vineyard. In early spring, midwinter's pruning shows off the nearly naked stalks, which have been protected through the cold. One day, a seedling, green and awkward, pokes out of the wood, encapsulated, and then sheds its skin as the cap begins to separate. At bud burst, a downy flower emerges with small white shoots. June progresses. The globes slowly take shape—first BBs, then peas—later sucking the sun's warmth and bulking up. Varying in size, they huddle from the small stem and multiply. Eventually the full sun of summer does its magic as *véraison*, color change, takes place as sugars are converted. Netting may keep birds, like those *merle*, or young blackbirds, that gave their name to merlot, and larger critters from sampling the grapes. The weather and the individual effects of location are carefully monitored, and as necessary, the natural processes are aided with leaf pull and irrigation. Then, *vendange*—harvest time.

Promises of another successful vintage: a rainbow curves over the barn of the 160-year-old Jones Farm. *Photo by Jeremy Pollack.*

Left: When the buds and flowers first appear in May, the long brown winter of the vineyard is over. *Courtesy of the authors.*

Below: Like many Connecticut winemakers, Steven and Catherine Vollweiler started in their basement and now run a huge operation with over thirty employees. *Photo by David Lebudzinski.*

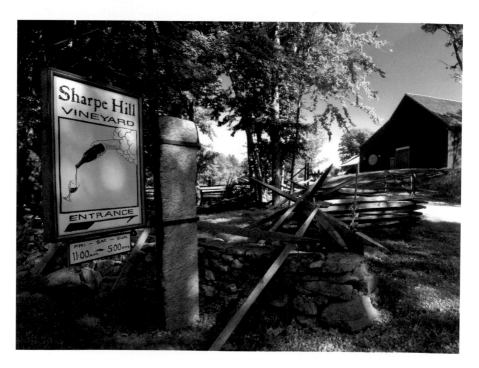

Vintners love the versatile nature of chardonnay, and it thrives in Connecticut's diverse regions. *Courtesy of the authors.*

In the beginning stages of *véraison*, grapes at Haight-Brown Vineyard start to ripen, slowly changing from green to purple. *Courtesy of the authors.*

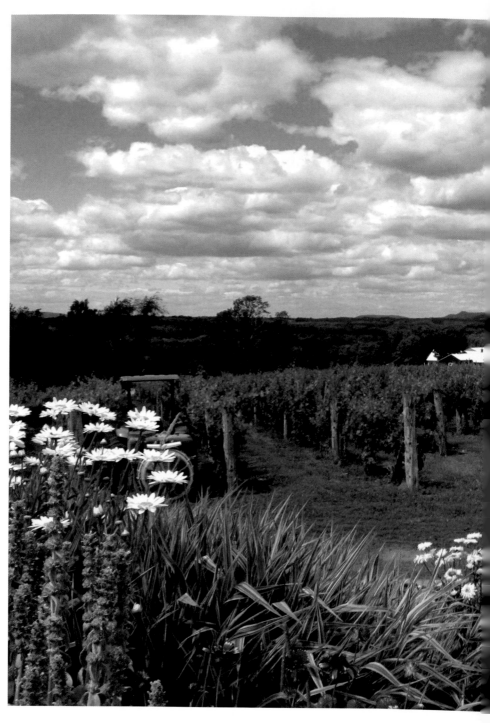

From the top of Whirlwind Hill, you can see across Gouveia's vines to the Hanging Hills of Meriden and Hamden's Sleeping Giant. *Courtesy of the authors.*

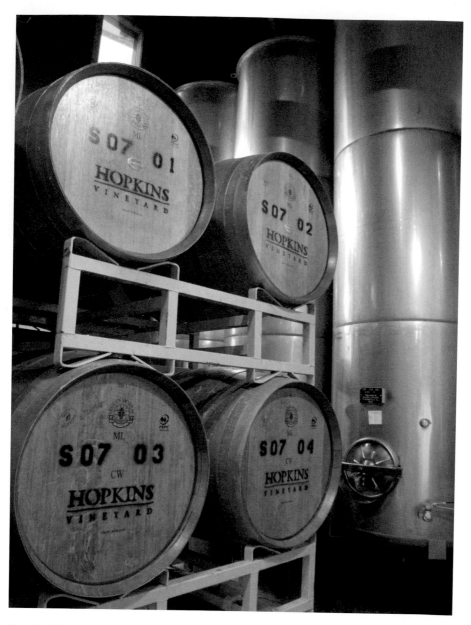

Hopkins Winery's choices of cooperage, age and toast level of barrels affect tannins and flavors like spice and vanilla. *Courtesy of the authors.*

Behind the iconic red door of Maugle Sierra Vineyard, guests taste outstanding st. croix. *Courtesy of the authors.*

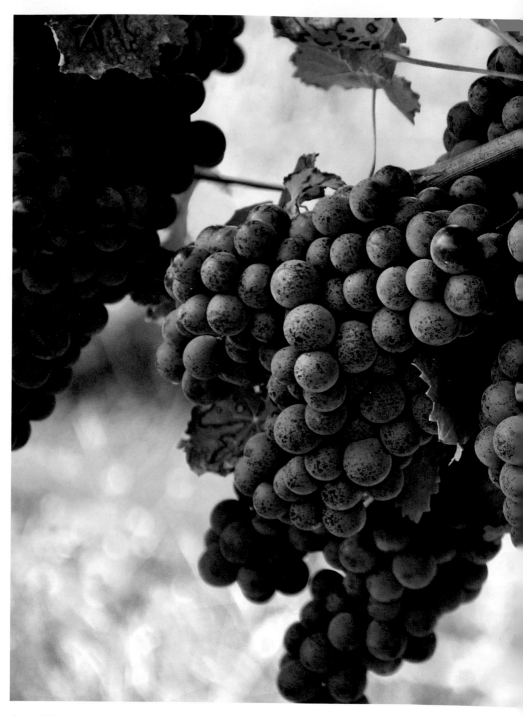

One of the parent grapes of cabernet sauvignon, cabernet franc has found a home in the soil of Connecticut. *Photo by Wally Kolek.*

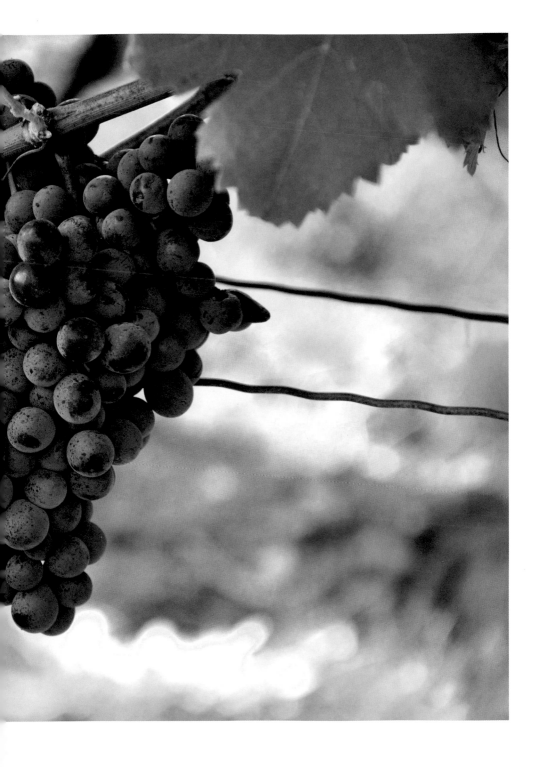

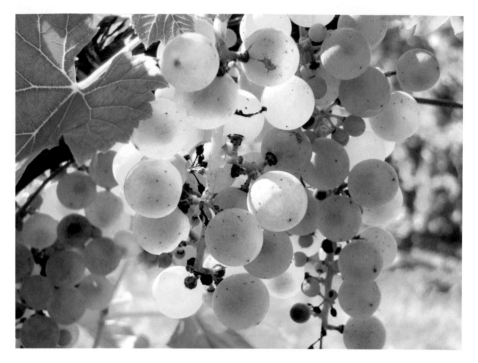

One of the many hybrids grown in the state, the seyval blanc grape produces wines with notes of citrus. *Courtesy of the authors.*

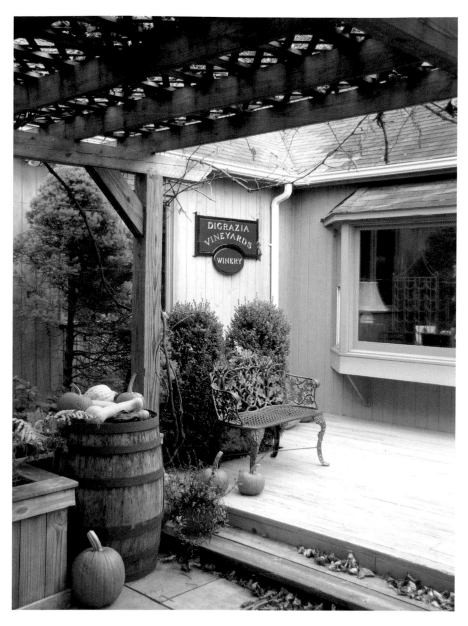

One of Connecticut's wine pioneers, Dr. Paul DiGrazia has carved his own niche with antioxidant-rich wines like Wild Blue. *Courtesy of the authors.*

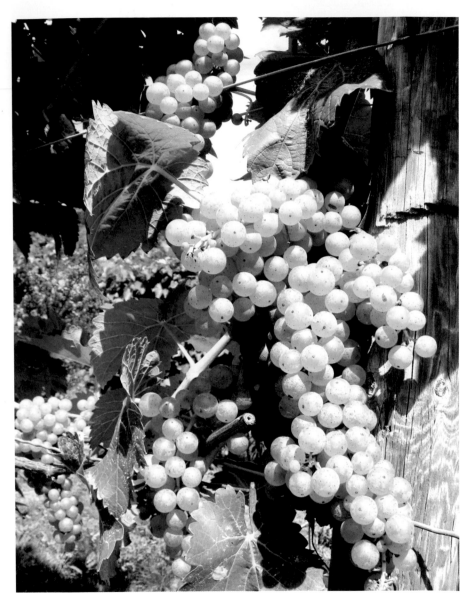

Vidal blanc shines in the August light. Vintners often remove leaves around the fruit to allow access to the sun and air. *Courtesy of the authors.*

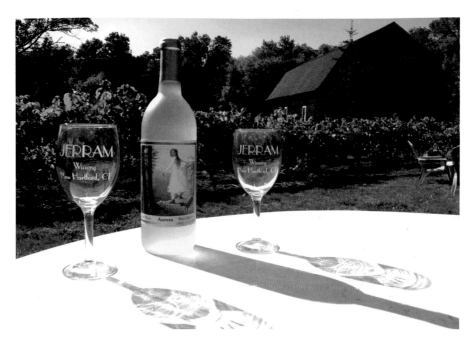

Blended with villard blanc, aurora grapes give Jerram's selection lemon notes and a hint of spice on the finish. *Courtesy of the authors.*

Wine swirling in clear glasses catches light and seems to gleam in the tasting room at Priam. *Courtesy of Priam Vineyards.*

Wedding guests enjoy the extraordinary rebuilt airplane hangar at Saltwater Farm Vineyards. *Photo by Seth Jacobsen.*

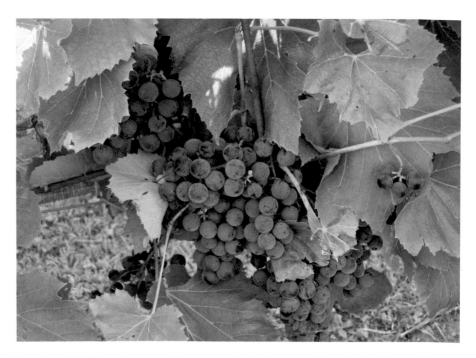

Developed in Wisconsin, st. croix has proven its hardiness and flavor in the Nutmeg State. *Courtesy of Taylor Brooke Winery.*

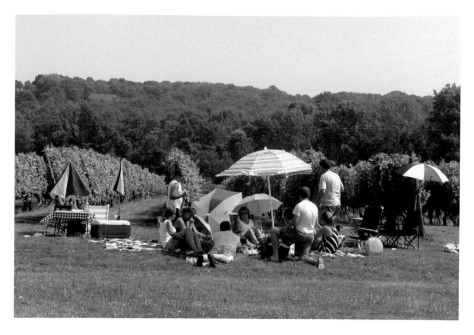

Beach umbrellas scatter across the lawn near the vines at Stonington Vineyards Summer Festival. *Courtesy of the authors.*

At an elevation of over one thousand feet, Sunset Meadows Vineyard's autumn comes early, but its grapes are protected from frost. *Courtesy of Sunset Meadow Vineyard.*

Snow falls on Taylor Brooke's tasting room, where visitors can still taste Winter Pomegranate before the season ends. *Courtesy of Taylor Brooke Winery.*

Vineyard in Your Backyard

While the tasks associated with vinification fill the entire year, most action begins in the fall as grapes are picked. With calloused hands and sweaty brows, vineyard workers across the state are quick to point out that despite the natural beauty of the vineyard in full bloom, hard work dictates what will become of these bulbs of sugar that hold the juice of future wine. While time and labor intensive, hand picking and hand sorting allow selection of the best bunches and are some of the many ways that wineries like Stonington Vineyard ensure quality.

Mike McAndrew, winemaker at Stonington, directs a tour of about forty visitors into the cellar of the winery. Tan from his summer work, Mike is dressed in shorts, sandals and a T-shirt with a nautilus pattern, with sunglasses hung around his neck. Though casually attired, he wears the uniform of one who muscles through his days with dirty hands, monitoring and modifying the vines, calibrating machines and tending the intricate process. Before taking on the duties at Stonington, where he has been since its opening in 1987, Mike worked at Haight Vineyards, where he began to perfect the technique of making Burgundy-style wines. In the Burgundy region of France, the *terroir* notably influences the grapes produced there, and winemakers consciously allow the soil and microclimate characteristics to distinguish the grapes of the region, like chardonnay and pinot noir. This philosophy of letting the grapes show off the land's qualities is apparent in the American Viticultural Area–approved wines of Stonington.

As we look on, Mike points out the equipment and its uses. Huge, thousand-gallon tanks, like giant mirrors, gleam behind him. The room is cool, and machines echo as he outlines the process, beginning with the crusher and destemmer, which can process five tons of grapes a day. An axle turns inside a metal basket, and an auger forces everything ahead to a pump and then through a large sieve, where the pulpy *must* is pressed.

Red and white grapes are readied for fermentation differently. Crushing occurs for all grapes, but for red wine, the skins join the *must*, as color and tannins, derived in part from skin, stems and seeds, are important. With white wine, only the juice is fermented, so the crushed grapes are pressed and the skins removed. Stonington's Triad Rosé incorporates cabernet franc, chardonnay and vidal, as only minimal contact with the red cabernet franc skins is allowed long enough to give Triad its dark pink hue.

Fermentation begins as yeast is added, and these tiny organisms begin their remarkable conversion of the grapes' sugars into alcohol, leaving behind carbon dioxide, which usually escapes into the atmosphere. While yeast occurs naturally on the grapes, winemakers rely on science and research to

Expert winemaker Mike McAndrew blends in like a tourist as he explains the Burgundian techniques used at Stonington Vineyards. *Courtesy of the authors.*

select specific types to guarantee results, as yeast can affect wine's flavor and complexity. Careful temperature monitoring ensures that yeasts act properly. White wine is fermented at cooler temperatures than red, but winemakers can adjust temperatures or stop fermentation for higher residual sugar levels. Secondary fermentation can take place, and this step converts malic acid to lactic acid, softening the wine. Forever in the background, the careful hands of time go to work to age the wine to perfection, but Mike's own hands attentively analyze every step. Eventually, tests for brix, pH, remaining sugars, acidity and alcohol are conducted in Stonington's laboratory as careful attention ensures the best wines.

Chardonnay is one white wine that can undergo malolactic fermentation, and Mike ferments it in French and American oak *sur lies*, where the wine is left beneath the dead yeast cells for eleven months. This process adds a toasty characteristic. One of the vineyard's newer offerings, Sheer Chardonnay, is fermented and aged in steel. This unoaked version shows off a different side of the grape's versatility, one showcased by vintners in Chablis. Steel fermentation and oak barreling work in combination with vidal blanc. Wine

artists like Mike can choose American or French oak, light or medium toast, and aging for wines like Stonington's Cabernet Franc can last twelve to eighteen months. Filling units siphon the wine into imported glass bottles, six at a time, which are then corked, a process that requires five employees' careful attention. Labeling can wait until winter or for a rainy day, but even then the operation is done by hand.

After the crowd filters out, Mike lingers to talk to a couple from Massachusetts who grow their own grapes. "You have to spray *vinifera* in New England," he tells them but cautions about using sulfur after Labor Day, as it can affect the quality of the wine. Despite the sometimes-frustrating intrusion of the many rocks in the soil, these are "part of the mineral quality of our wine," he notes. The expertise Mike McAndrew imparts to these hopefuls is invaluable, encouraging amateurs to become professionals and perhaps even artists.

But the depth of the vineyards' complex needs go mostly unnoticed by the public. As farmers and winemakers collaborate, much time is spent tweaking the vineyard, ever searching for things to improve. For example, Tony Ferraro from Connecticut Valley Winery has been working with different enzymes to get the color of the wine to be exactly what he wants. The ideas of trial and error are considered frequently and without apology. Though largely a seasonal operation, there is, in effect, little downtime on the vineyard. "It's a lot of work to grow grapes. There are about six weeks when you don't have to work with them, from October to December," says Steven Vollweiler from Sharpe Hill. Couple this with the rigors of running a tasting room, and the romanticism, though perhaps not the magic, seems to evaporate like summer rain.

We know this to be true: wine manifests on a canvas where human hands reach out to touch the miracles of nature. We may sculpt the raw materials and tinker with the results, but in the end, we trust that the rain will fall, the sun will warm the earth, the transference of energy will persist and what we know of chemical processes and biological outcomes will serve us well. It is both in our hands and out of our control. Who said making art would be easy?

9

EASTERN PHILOSOPHIES

E veryone knows that philosophy is best discussed over a bottle of wine. This is even more true when discussing the various ideas and values surrounding winemaking itself. In Connecticut, the discussions have changed over the centuries. At first, colonists argued whether to import from Europe or make wine at home. As the nineteenth century progressed, wine became a moral issue. In the twentieth century, it became a legal one, with the knot of regulations accompanying Prohibition. "It set us back decades. We are just now recovering from bad policies," Gary Crump of Priam Vineyards says. In fact, laws prohibited growing grapes and making wine "unless you had a priest on the property making wine for the church. Amazing, you could drink in church but nowhere else."

In the twenty-first century, as the state unwinds itself from the tangled mess of legal restrictions, the arguments turn to more subtle measures of growing, brewing, selling and shipping. Sometimes outside forces intervene, like when the U.S. Supreme Court made it easier for wineries to ship directly to customers in 2005. Sometimes a new winemaker champions a new method or presents a new paradigm. And sometimes two value systems collide in the seemingly peaceful environs of a vineyard.

No one exemplifies these conflicts more than iconoclastic winemaker Jonathan Edwards. At his beautiful white barn in North Stonington, people crowd around the custom-built wine bar and roam the charming green fields. Edwards wanders in from the vineyard, calling for a glass of wine, sweating and dirty from the hard work of the day. Someone recognizes him, and he humbly shakes hands. We head out onto the porch to discuss philosophy amongst his allies, the farm's cicada-killing wasps.

Jonathan relates how he traveled through different wine regions of Virginia and Long Island and then worked under Vincent Arroyo in Calistoga, California. "As a family we got excited about owning a business and got excited about wine." He wanted to be part of the action in Napa Valley, and in 2000 he bought grapes from growers there, rented space at a winery and brought the resulting wine back to Connecticut. No one else in the state has taken this approach, probably because this is not an easier way to make wine. It's more work, requiring Jonathan's presence in California every year to supervise the hand picking of grapes and the beginning of the winemaking process. Refrigerated trucks bring the young wine to Connecticut for barrel aging and bottling. "We go there, are there for harvest, there for fermentation [and] bring the young wine here. Very different than getting ten tons of merlot shipped…and more expensive."

Some think this is controversial, and if Edwards was pretending this was Connecticut wine, it would be. But he is more than honest about its origins; he is proud. Other wineries who bring in a high percentage of grapes from other states to make wine must call it "American wine." But Edwards can put the Napa appellation on the bottle, because he makes the wine in California. "We wanted to make premium wine, high-end wine, Napa wine." And if an outsider wants to make Napa Valley wine, this is the only way to do it. Building an elaborate, beautiful winery where people can gather is impossible in Napa today. Besides the outrageous price of land, the rules are strict, tasting rooms are prohibited at new wineries and events like weddings or festivals are forbidden.

Furthermore, what Edwards is doing is not unusual. Around 95 percent of California wineries don't grow their grapes and are what they call "boutique wineries," as opposed to vineyards. In Connecticut, such definitions are more problematic. It would certainly be difficult to call Jonathan Edwards a boutique winery. After all, he has his own Connecticut vineyards. "The plan was to have both Connecticut and Napa wine," he says, waving around at the hundred-year-old white barns and acres of vines.

The huge barns were once part of Fairview Farm, a dairy cattle operation, and then became Crosswoods Vineyards in 1980. Two of the early Connecticut wine pioneers, Susan and Hugh Connell, fought off hungry birds with a shotgun loaded with blanks, opening to the public in 1983. Winemaker George Sulick made a chardonnay so good that a wine store owner in far-off Litchfield bought 13,200 bottles after a blind taste test with two white burgundies. The thirty-five-acre vineyard was noted as "the standout winery in this state" in 1989 but closed two years later due to financial difficulty.

Iconoclast vintner Jonathan Edwards brings the flavors of Napa Valley to Connecticut. *Courtesy of Jonathan Edwards Winery.*

Ten years later, Jonathan Edwards bought the farm as a turnkey operation with no inventory. He had to rip out the vines, which after ten years were in terrible shape. The hill had a lot of groundwater on the surface. The Connells could literally take a vine by the stem and pick it right out of the ground because the roots spread out. Edwards found this unacceptable and built the only fully tiled vineyard in New England. He also decided to plant only *vinifera* grapes, acknowledging that hybrids grow great but "that's just not what we're trying to do." These local operations took a long time. When he opened in May 2002, he had five wines, all Napa.

In 2010, it is a different story. Now chardonnay, pinot gris, gewürztraminer and cabernet franc grow around the old barns. Edwards wants to keep doing half of each state, highlighting varietals that grow better in each climate. "Plus, it's fun to be part of that industry out there. The knowledge base is incredible. It's really neat to go and soak it up for a month during harvest and get refueled and refired. To bring some of that back here." It's certainly working for him. Edwards's winery is a hugely popular venue for weddings.

Vineyard in Your Backyard

It ships almost everywhere in the United States, and he makes house wines for places like Foxwoods and Mohegan Sun Casinos.

Their Napa Valley Zinfandel is good, but we prefer the Estate Cab Franc, which is warm and earthy, with vanilla notes. We also prefer the estate-grown gewürztraminer to his Napa Pinot Grigio, enjoying the crisp, dry lemon taste. It's possible we are a little prejudiced, though. He is not offended at all when we tell him, saying, "I love our Connecticut stuff." And when we ask if he'll ever change the dual nature of his winemaking business, he shakes his head. "We've built a nice niche for ourselves. Why pull the plug on it? We have a lot of customers who come here specifically for that Napa wine."

A few miles away on the shores of Lake Amos in Preston is one of Connecticut's newer wineries, Dalice Elizabeth. Mary-Lee and John Wilcox, along with their grandson, Blaze Faillaci, named the winery after Blaze's mother, who died in 2000, dreaming of owning a winery. Their contemporary farmhouse holds a commercial kitchen where they host events like wine dinners. The Wilcox family planted their vines, but while waiting for them to come to fruition, they have been importing grapes to make "American wine." They give a delicious tasting menu of cheese, bread, olives and antipasto, which complements their other focus: Italian cooking classes. Their crowd-pleasing, heavily oaked varietals are what the traditional consumer of wine has come to expect: cabernet sauvignon, merlot, zinfandel, chardonnay, pinot grigio, sangiovese and syrah. Dalice Elizabeth is giving the consumers what they want, and their focus on events, food and a selection of wines we expect to see in the package store is smart business.

But just down the road in Ledyard is another winemaker with a completely different approach and his own passionate ideals. Almost every vineyard in Connecticut diversifies for the customers in some way, growing or making a selection of red and white wines, dry and sweet. Paul Maugle takes a more European approach, specializing in just a few wines and concentrating on doing them well. For years, he refused to build a large area for events, saying, "I don't care about yield," perfectly happy to make "parity" with his business. He is much more interested in focusing on producing the highest-quality wine from the grapes he thinks do best in his microclimate. It is a purist approach.

Through the big, red doors behind the historic 1740 Ledyard House, in what used to be a billiard room, Paul Maugle sits with us over a bottle of a st. croix–merlot blend named for the house, jammy and perfectly balanced. Not surprisingly, we have to steer him away from talking about the "nuance and flavor" of the wine to tell us about his life and philosophy. He left

Connecticut at age twenty-three and came back at forty-six. In those years, he traveled the world, learned multiple languages and received a doctorate in food science in Japan. In 2002, he was offered a job in Djibouti but turned it down, and he and his wife, Betty, bought a farm in Connecticut instead. "This for us is coming back home."

The farm is only one hundred feet above sea level, but located less than five miles from Long Island Sound, this is sufficient for growing grapes. In fact, the farm already had some hybrids and *labrusca* grapes but was overgrown with young trees. Paul cleared twenty-eight acres, took down the internal stone walls and sold the unnecessary equipment. Unlike Jonathan Edwards, Paul decided against planting *vinifera* grapes because he would rather have "vines that survive." He always tries to harvest before hurricane season. Also unlike Edwards, Paul believes in doing things locally, and all the grapes he brings in are from Connecticut, Long Island and right across the border in Massachusetts. In California, they have "more sugar, less acid." Instead, like the winemakers of Beaujolais, Paul takes out the seeds of the more acidic Connecticut grapes, reducing the tannins and making them softer, smoother and easier to sip. "Seeds have woody tannins, skins have softer ones," he posits.

A couple traveling from Foxwoods Casino stops in. He educates with lines like "three sips, each one should be a little different" and learns with "which one did you like? What about you, sir?" Paul is polite and knowledgeable, as a server should be. With us he talks science, enzymology. "You want to taste the fruit, not the barrel." He explains the problems with trying to bring out a certain taste in a wine rather than letting it lead you to its own taste. He talks about his favorite grape, st. croix, selectively picked and cold fermented in small batches. Sometimes he makes a dry rosé with it, "for lobsters." He also has traminette and cayuga and is planting marquette. As we talk, the red opens up, adding a caramel finish. "If you can sense the unfolding of the flavors, that's what you want to do."

Paul's rhetoric is very convincing, and drinking glasses of his fantastic wine, we get a remarkable illusion of timelessness and purity. But even a purist like Paul Maugle must make certain concessions. He admits to sometimes changing his approach, though not with the wine. He used to keep the deer away by the frugal method of putting chicken wings on the ends of his trellises to bring in coyotes. Now he has three miles of deer fencing but keeps the gates open at the bottom "so that the coyotes can still sneak inside to eat those grape-stealing rodents." He even bought more French oak barrels recently. "It's a different year," he muses, stroking his signature beard, a little whiter than when he served us years ago.

Vineyard in Your Backyard

A young woman comes in and asks about a party next month. He has finally bowed to the necessity of hosting musical nights, started wine dinners and even hosted a festival in 2010. Though his tasting room with its leather chairs and fireplace is beautiful, it is one of the smallest. He is expanding to be able to do larger events. However, he is quick to point out the difference between him and some of his competitors: "We started with the vineyard. We spent eight years making sure the wine is right first." Paul nods, smiling. "I was in to drinking the wine. It grew into something else."

Still, for many, winemaking is only part of the equation. Taking the roads north along the Quinebaug River into the Last Green Valley, you can find Heritage Trail Vineyard in Lisbon. We had tasted here on summer mornings in the old barn by the frog pond, enjoying Estate-Bottled Quinebaug White, with its green pepper notes, and the cherry and chocolate aromas of Shetucket Red, made with the rubiana grape. At that time, Heritage Trail was owned by its founder, Diane Powell, but had languished for a few years before being bought in 2008 by chef and author Harry Schwartz and his wife, Laura. They renovated the 1785 house, built an event pavilion and added a restaurant. Needless to say, a television chef who has cooked for celebrities around the world is focused on food as well as wine. He opened a restaurant and looks forward to a bakery and gelato shop. Fine wine for Schwartz means fine dining, and while his wife concentrates on the wine, he uses the beautiful vineyard as a springboard for a larger business plan.

Farther into the Last Green Valley national heritage corridor, a new winery is just establishing itself in Patriot Nathan Hale's old stomping ground of Coventry. Owner Bob Chipkin's move to build a commercial winery on the former dairy farm happened slowly. After buying land in 2000, they waited five years to start making wine and five more to join the Wine Trail. Now, Cassidy Hill's beautiful pinewood tasting room gets a lot of traffic from nearby University of Connecticut. For Coventry White, a semisweet white blend, they are now able to use home-grown grapes. Meanwhile, they import grapes from California and Chile for some of their wines, using the classic Australian method of adding oak chips. The 123-acre farm has plenty of room to expand from the 12 acres planted now on the south slope of the hill, and who knows what will be planted and what will be made from those grapes. Only time will tell what Cassidy Hill Vineyard's lasting values will be, and you can be sure Bob Chipkin is in no hurry to make up his mind.

A dozen miles north on another lofty hill, eight hundred feet above sea level, Taylor Brooke Winery is a small but intensively planted vineyard with more vines per acre than most. Paul Maugle got advice from the owners,

Dick and Linda Auger, and they also work closely with Holmberg Orchards and nearby Westford Hill Distillery. Like Paul Maugle, they just built an addition and revamped their tasting room. Also like him, one of the first things Linda Auger tells us is: "We want to be different."

The Augers pioneered the use of the traminette grape and chose riesling instead of chardonnay, one of the first vineyards in Connecticut to do so since Jonathan Dickerman's failed attempts 150 years earlier. But their differences are not just in their chosen grapes. They are one of the few wineries to infuse their wine with fruit, with the idea that they would be "a little bit sweeter and fun," something to bring in those who usually drink white zinfandel. Their Green Apple Riesling even appeals to beer drinkers. Some in the industry look down on this practice as a dilution of the pure grape wine, and they may have a point. But Linda defends the choice, saying, "It shouldn't be serious. God knows there's a lot of serious stuff out there. Wine should not be it. It's a beverage. And you know it's nothing more than that...let's put it in perspective here."

Taylor Brooke's "vineyard dog," Zima, was recently featured on the front of the Official Connecticut State Tourism map. *Courtesy of Taylor Brooke Winery.*

Regulations are another sticky issue. Although the Augers far exceed the state requirement for a farm winery as far as percentages, using 60 percent of estate-grown grapes rather than the required 25 percent, their vineyard acreage is slightly too small to comply with land-use standards. Linda shakes her head. "Why do they care?" This limited growing area also leads them, like many small Connecticut vineyards, to bring in grapes. Their cabernet franc is a case in point. It is light and dry, with an amazing mocha nose and finish. They do not get this effect, as some wineries in California do, by adding merlot or sauvignon. They simply use toasted Hungarian oak and leach out some of the tannins. However, they also use 50 percent grapes from Connecticut and 50 percent from New York. Does this count as a Connecticut wine? According to law? According to opinion? Which matters more? Who decides? We can only acknowledge that it is one of the best cab francs we have ever tasted.

"If everybody did the same thing in the state then nobody would be unique," Linda says. Jonathan Edwards echoes her: "We are unique. We're just doing our own thing." And some think that uniqueness should be celebrated, not regulated. Other disagree and point out that without strong rules and oversight, Connecticut wine will never achieve the reputation it deserves. One thing everyone agrees on is that we are a small state with lots of geographic and climatic differences, and it is the winemaker's philosophy that determines what the wine will be. We can only hope that everyone takes a cue from at least one element of Paul Maugle's philosophy and focuses on the nuance and flavor of life. We should also understand that what leads to these different points of view is a tense historical situation. But that situation will not improve with time; it will simply change. The vines will grow, the bottles will age and the discussions over glasses of wine will continue. We should hope they do. Because whether we agree or disagree, when ideas stop fermenting in the steel vats of public discussion, the result is always bad wine.

10

Eat, Drink and Stay Local

Food and wine have gone together in most cultures for millennia. Since alcohol acted as a preservative and provided a necessary alternative to unreliable water sources, it became an important component of ancient households. Preparation of meals meant taking advantage of what was locally available and seasonally grown, easily prepared and safeguarded for storage. Wine fulfilled all these needs, and its use grew as cooking methods developed. Over time, farmers and vintners gave greater attention to how food and wine worked together, learning to find the perfect balance between savory aspects of lamb or beef and the acid and tannins of wine. As cheeses were aged and perfected, so too were wines. Agricultural practices expanded, linking what the land provides and what the table bestows in our consciousness.

In the early days of America, common practices included not only pairing food with wine but also tinkering with the flavors of the wine itself. Recipes for mulled wine, for example, would have been in an early Connecticut housewife's collection. Given that colonial winemaking probably left much to be desired, mulling helped to lessen the astringent taste of homemade wine. Such recipes included a notion to "boil the spiceries" such as cinnamon, cloves, nutmeg and mace "in a quantity approved," then add water, a pint of port and sugar to taste. Serving the warmed liquid with toast was common. Specialties like egg caudle were prepared with yolks mixed in the mulled beverage. Versions of Sack Posset, which called for madeira, were probably concocted with a fortified home-brew and grated nutmeg. The mixture was then placed before the fire to set. One version cautions, "In pouring

milk into eggs and wine, hold hand very high and stir consistently." Perhaps the woman of the house was preparing for the coming holidays, helping daughters and nieces learn family recipes.

With berry bushes, fruit trees and grapevines among the various crops in Connecticut, families kept operations like milling, canning, cider pressing and winemaking close to their sources. But as improvements like refrigeration developed, the need for local food and provisions seemed to dwindle. As trade increased, it was considered a novelty to be able to get fresh food at any time in any place. That idea morphed into the wrong-headed cultural notion that "if it is from around here, it must not be very good," offers Margaret Chatey from Westford Hill Distillery.

As immigration increased and new customs and cuisine permeated the country's landscape, tastes opened. Food and wine from all parts of the world have become available to us today. Ironically, as our international palate grows, our relationship to native bounties suffers. Luckily, that connection has begun to be slowly reestablished, thanks in part to Connecticut's wineries. Many offer wine dinners or cooking demonstrations to reacquaint tasters with wine's innate ability to bring out the best in food.

An energetic summer squall flashes across Lebanon as we make our way on Route 2 into Colchester. Streams of water tunnel into the driveway of Priam Vineyards, and with only an hour or so to spare, Gary Crump powers up the tractor to smooth the gravel. Luckily, the sun comes out before we embark on a "wine dinner field trip," escorted by Priam wines and food prepared by Rob Appucci, chef and owner of Vito's On the Park Restaurant. With the late afternoon light now filtering over the vines, a humid mist settles around the tasting room patio as guests mingle and watch for butterflies and bluebirds. We sit with Dimetrius and TasJuaii, who are on their first date, and by the end of the evening we have shared laughs, stories and even a few blackberries.

Flowerbeds shine with wet rain, and the vineyard sparkles after the storm. The pairing of Priam wines and Rob Appucci's cuisine began with a bottle of Salmon River Red that Gloria Priam was taking to her accountant. Rob's mother happened to be in the office that day, and knowing her son was a world-class chef, the accountant offered the bottle to her. Rob acknowledges that he works well with Gloria and Gary because they have a similar passion for what they do. This is their sixth year, and it has only rained once. "I can't do a lot, but I can control the weather," laughs Rob as he addresses diners in jeans and an apron. "Every year I get to try new wines," he says slyly.

Gloria and Gary join us on the patio for dinner and tell us about the wine. Our tablemate TasJuaii is a serious taster, sporting a backpack with

Gary Crump and Gloria Priam like nothing better than introducing people to their delicious wine. *Courtesy of the authors.*

her own black linen napkins and wine glasses. As the sun sets, the small patio lights halo the porch, and we begin with the first course: panzanella salad. A bed of tangy mixed greens covers grilled focaccia. The appetizer pairs perfectly with Blackledge White, as the salad's acidity brings out the wine's smoothness. The wine also has a good amount of acid, with less than 2 percent residual sugar, but joined with the appetizer, it becomes deliciously creamy. Our palates are set for course two.

Experts like Gary and Rob know that wine pairing is partly about linking characteristics of one to characteristics of the other. It seems easy when they do it, but the perfect marriage might elude others of us who might have been brainwashed under the simplicity of "white wine with fish, red wine with meat." Luckily, opportunities like these dinners intrigue us into attention, as we can carefully monitor our own palates' interactions with the prepared choices. We are treated to portobello mushrooms stuffed with crabmeat. The mushrooms sing of savory earthiness, and the crabmeat drips with spicy aioli, each complemented individually and collectively by Salmon River White, a blend of riesling and muscat. In the tasting room, we got smoky

tangerine and a vanilla finish. At dinner, it is slightly astringent on the nose, with clove in the middle and a little petroleum, which, rest assured, is not a bad thing but is connected to the mineral notes imparted by soil. Marinated in balsamic vinegar, the mushroom combines with crab salad for a playful spin on "surf and turf." The flavorful, creamy combination brings out spice in the Salmon River White as the rich, heavy seasoning of the aioli makes the wine equally creamy. This is a good example of how to pair seemingly different textures and flavors like seafood, mushrooms and the velvety egg and oil sauce. A slightly acidic, slightly sweet white is perfect.

Our third course showcases riesling paired with salmon and risotto. Rob explains that he first tried a dish like this in Florence, and his approach includes drizzling a sweet chili *beurre blanc* over the pistachio-crusted fish. Even though asparagus is one of the hardest foods to pair, the risotto is not overwhelmed by it, and savory and spicy relate nicely with the citrus notes in the riesling. Next, we are reacquainted with Salmon River Red, and it does not disappoint with its smoky berry nose and peppery finish. The hearty, full-bodied, Bordeaux-style blend of cabernet sauvignon, cabernet franc and merlot is a solid accompaniment to the New York strip dusted with porcini mushrooms and served with roasted potatoes. Foods with texture and weight like steak seek wines of equal heft and strong tannins.

As we talk and enjoy Rob's creativity and Priam's expert wines, we continue to be enticed and glance over to catering tables, where sous-chef Steve whips cream by hand into a fluffy mound. Soon enough, Late Harvest Riesling fills our glasses, and our plates receive lemon tart. Following the adage that opposites attract, the chef has chosen the pastry, which is not too sugary, to pair with the dessert wine. Light in color with lavender notes, the wine's acidity balances with sweetness, and sipped slowly as the evening winds down, it is lovely with the baked crust and lemon filling. Gary said it is "the nicest late harvest we've ever harvested. We were lucky to get it." They've made late-harvest riesling only four times; three of those won gold, and one took silver.

We learn that whether we are preparing Thanksgiving dinner for our family, burgers on the grill or soup from a can heated on a lonely burner, a few general principles can go a long way as we attempt our own perfect pairings. Crisp, high-acid wines go nicely with both spicy and savory; a hearty red belongs with substantial meat; and sweet and tart can be perfect together. Look for the dominant characteristic of the meal and link it to that of the wine you are serving. But since everyone's palate is different, know these are only suggestions—the real test is to find what you like.

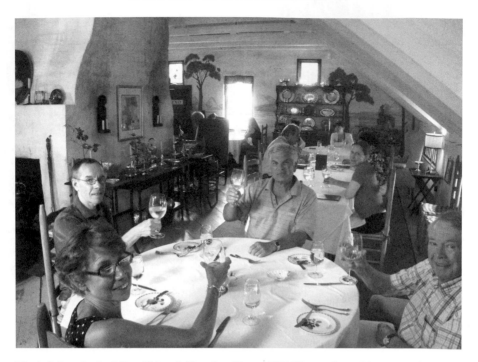

Nestled deep in the hills of historic Pomfret, Sharpe Hill Vineyard provides great wine and great food at its exclusive Fireside Tavern. *Courtesy of the authors.*

At home, we made our own *beurre rouge*, a butter sauce made with red wine and shallots, and poured it over tilapia. Recipe books would have prescribed white, but we happened to have an open bottle of red on hand, and it turned out to be exquisite. If you want to bring out the sweetness in a dry wine, try for something slightly salty or acidic in the main dish. Foods rich in *umami* bring out tannins. We opened Black Tie Cabernet Franc from the Connecticut Valley Winery for a dinner of baked chicken thighs with crunchy shallots and spicy dipping sauce made with ketchup, miso, fish sauce and red pepper. With 75 percent cabernet franc, this red gets a little sweetness from the geneva grape but also imparts cab franc's signature earthiness. Our savory meal highlighted the subtle fruit, and the pepper finish worked even with our spicy sauce.

Some wines stand out for us because of our association with where and when we drank them. The bubbly you toasted at your wedding may not have been of the best vintage, but it is the best wine by virtue of the fact that it was experienced on that day. Whether traveling across the state or staying at home, wine's effect on our palates is as much connected to place as the vines themselves. And when we realize that wine is inextricably linked to place, we

necessarily begin to make that connection we once upheld so easily: local, accessible, seasonal food and drink connect us to home.

At the Harvest Kitchen at Jones Family Farm, connecting us to home means connecting to the land. Jean Jones, a nutritionist and registered dietician, is married to Terry, fifth-generation Jones, and she is quick to show her enthusiasm for gathering people, sharing food and wine and fostering the love the Jones family has for local, sustainable, fun and healthy food. Terry lets us know that one reason the farm has survived for six generations is because of "the remarkable women we have brought to be our wives." It is clear they have the right formula, as the winery has taken off, and the new commercial kitchen hosts community events that spread the word about inspired eating.

In the brightly lit kitchen, the table is set for guests as you would expect at a family gathering. Around the room, colorful handmade quilts hang with kite, pinwheel, star and teardrop designs. Old black-and-white photos stand in black frames on shelves. We're treated first to Currant Affair juice, made from local black currants by a company out of Preston. We begin dinner with corn chowder, made using fresh, simple ingredients straight from the land: potatoes dug from Jones's garden, corn from Stone Gardens Farm, cream from Farmer's Cow Cooperative. Each creamy slurp of chowder showcases individual flavors working together. Tonight's wine, Stonewall Chardonnay, was incorporated in small splashes, unifying and enhancing the flavors in the soup and in the glass.

Chef Sherry Swanson treats us next to Jean's version of North Carolina–style pulled pork sandwiches, which are more vinegary than spicy, served with coleslaw and couscous salad with roasted vegetables, straight from the farm. Dinners like these allow us to connect with the people who are producing the food. Allyson Angelini, who manages the gardens and organizes classes, took care of the pig we had for dinner. Later, she cannot help but beam with pride as she relates the story of her chicken's first eggs.

With dinner, we drink Stonewall Chardonnay. The fresh coleslaw adds additional zest to the already tangy pork; it's also an added textural component. As for the wine, the chardonnay is pale in color and off dry—not oaky, a great dinner wine. Lemon notes come out when the mouth is still contemplating the pork. Acid is an important element of wine, as it helps to balance and define flavors and contributes to that mouth-watering quality. A good rule of thumb when pairing is to match levels of acid. With tonight's meal, the vinegar crunch of our sandwiches and the crisp cleanness of the wine work well together—the fruit is more pronounced, which makes the wine taste better. One of our fellow

diners mentions that she is not a chardonnay drinker, but she likes Jones's version, light with a hint of butter in the middle.

Everyone knows that wine and cheese make for excellent companions, and we sample local delights from Beltane and Cato Corners Farms. A creamy chevre with *herbes de Provence* brings out the fruit of the chardonnay. The first of our hard cheese selections, Bridgid's Abbey, is mild with notes of truffle. Bloomsday is aged seven months longer and is thus more pungent, sharp and salty, but both are nicely smoothed out by the wine. Some suggest selecting a cheese and a wine from the same region, and in Connecticut that's easy, as ample supplies of both are available.

After watching the PBS documentary *Working the Land: The Story of Connecticut Agriculture*, we finish off with a round table discussion of the fate of farming in the state. As we talk, we enjoy dessert of cobbler, made with peaches from Bishop's Orchards, topped with ripe, bulbous blackberries from Jones's own bushes and ice cream from Ferris Acres, the last working dairy farm in Fairfield County. Our hosts are understandably philosophic, as they know sustainability is important not just to keep farms healthy but also to keep food on everyone's table. "There is a clear economic incentive to sustain and develop farming in the state," Jean says, "as a higher percentage of farm production yields more jobs and greater economic potential." Allyson agrees: "Honoring our food is a really important first step."

When pairing, honor both food and wine. Look for compatibility, bring out understated notes and try not to overwhelm one with another. While a complex Venn diagram showing the relationships of parts may help those of us who are novices, the biggest part of the equation is the pleasure of successful experiments. Often, success is serendipitous. We happened to pick up chorizo instead of salami, and we wanted to try Coventry White from Cassidy Hill. Without much thought or preparation, we drank an aperitif with black kalamata olives and slices of meat. The wine imparted notes of grass, with orange in the middle and lemon on the finish, and blended perfectly with the salt and spice. Another experiment was toast with avocado brushed with balsamic vinegar, which we enjoyed with Sunset Meadow Vineyard's Twisted Red. The avocado's smooth richness helped to bring out this red's light tannins, mellow the fruitiness and enrich the earthiness.

Whether we decide to poach fish or linger on the patio with kielbasa, vineyards around the state will provide wines to match. And if we do choose locally grown, seasonal food, we inspire people, as the Harvest Kitchen does, "to return to their kitchens and return to the land." Margaret

Chatey of Westford Hill Distillery says proprietors, farmers, cooks and shoppers "are beginning to grasp the idea that if we don't buy the product the farmer's growing, he's not going to be there much longer." Wine and food will always be available from exotic places, and taste will always be subjective. Seeking the perfect pairings is about exploring possibilities, and when we find them in the backyard, we support a rich apothecary of dairy and meat farms, organic markets, bakeries, apiaries, orchards and wineries making great wine.

11

THE ESTATES OF THE
WESTERN HIGHLANDS

G eorge and Judy Motel's accountant couldn't believe they could make a profit just by putting a sign out front. But Sunset Meadows Vineyards in Goshen did more than that in only a few years. We stopped at their tasting room, with its original hand-hewn beams and antiques, almost immediately after they opened and have returned to taste their wines time and time again. Their Cayuga White has a peach nose and a pear finish. Their Sunset Blush, a mix of seyval, vidal and merlot, is floral but not too sweet. And their St. Croix has the subtle fruit and pepper combination so often talked about and in reality so rare in American wines. "It has numbers just like a California wine," says Judy. Traveling the Wine Trail, we kept hearing the name Sunset Meadows. "One of the best ones," a fan told us. But what was surprising was the respect given to this relatively new winery by the titans of the industry. Judy and George might have the highest winery in the state at thirteen hundred feet above sea level, but they clearly have something else as well.

The Motels raised beef cattle at this farm for years before they became grape growers. Then, at a fundraiser, the president of the Connecticut Wine Association at the time, Gary Crump, suggested grapes. The soil tested well, so they planted two acres of cayuga, keeping the cattle. The grapes did "very well," and in 2000 they plunged full force into growing grapes, selling cayuga and st. croix to other wineries. Not satisfied with just growing, George and Judy decided to become vintners. They traveled to California, Italy, Long Island, the Finger Lakes and Virginia to learn what to do and what not to do when starting a winery. Knowing he would either have to do

the work himself or hire a winemaker, George enrolled in the Viticulture and Enology Program at the University of California–Davis, completing four years of distance education while still an executive at a grocery wholesaler. "We threw ourselves into it wholeheartedly," says Judy. "To operate a tractor, plant, prune, till…you need to be resourceful."

They converted the dairy barn into a production room and ordered special tanks to fit their unusual building. Their collie, Kansas, helped to keep the deer away from the young vines. Though new to the wine community, George had long experience in the food industry and was tagged as the perfect person to set up the Connecticut Wine Festival. Since the first years, the Motels have planted more and more, looking to see what works, finding the perfect grapes for their *terroir*. "We just want to make the best," says George, pointing to the long row of awards on the wall. But this story sounds a lot like the other success stories in the history of Connecticut wine. What made the Motels special? It was their decision to try to keep a few simple words on their bottles.

The reason so many wine lovers compliment Sunset Meadows is because the wine is very good. But the reason other winemakers compliment the Motels is because so much of their wine is grown on site, because of their focus on "appellation" wines. Technically, we have "American Viticultural Areas" rather than appellations, like in France, but everyone seems to call them that anyway. But what are they? What is the difference between a Connecticut wine, an appellation wine and an estate-bottled wine? Why are these distinctions important? Shouldn't we just care about how a wine *tastes*?

The idea of wine appellations goes back at least to the Bible, but the first officially recorded vineyard protections and regulations were in Chianti, Italy, in 1716. Fourteen years later, Tokaj-Hegyalja in Hungary introduced the first authorized wine-classification system. Believing each region to be unique, the French became meticulous with their regulations and appellations and inspired the rest of the world to do the same. In America, the Augusta, Missouri region was the first to receive the American Viticultural Area designation in 1980. Napa Valley followed, and in 1984, the Southeastern New England AVA was established, defining a climatic *terroir*. The region is characterized by loamy soil over glacial alluvium and is strongly influenced by the ocean waters, which moderate temperatures significantly. It encompasses almost two million acres from New Haven County across Rhode Island to southeastern Massachusetts, about a third the size of Bordeaux. "It allows me to use grapes from nearby lands that share the same characteristics," says Nick Smith of Stonington.

In 1988, the Western Connecticut Highlands was designated an AVA, mostly through a three-year effort of Bill Hopkins to prove that these hills of glacial schist and granite were a "distinctive land area." "We're a little bit different than the rest of the state, climate-wise and [in] topography. I just thought it would be nice to have our own area. Plus you can't use the words 'estate bottled' unless you are from a viticultural area," says Bill. The highlands include all of Litchfield and parts of Fairfield, New Haven and Hartford Counties, all in all over one million acres, twice the size of Napa County.

Connecticut laws require 25 percent of the grapes to come from the property to be considered a farm winery, and federal laws require 75 percent grown in state to be labeled Connecticut. But for an AVA-designated label, you must grow 85 percent. To be labeled estate grown or bottled, 100 percent of the grapes have to be planted on the property. You have choices. Jonathan Edwards uses "Connecticut" on his wines rather than "Southeastern New England," even though his home-grown wines qualify for the latter label. For Hopkins, estate wine is the ultimate goal. "We do take pride in growing our own grapes," says Hilary Hopkins Criollo, who has more estate-bottled wines than any other vineyard in the state. She and Hopkins's winemaker, James Baker, try to encourage other vineyards like Sunset Meadows to shoot for this mark.

The Motels take this advice from Hopkins very seriously and use the Western Connecticut Highlands appellation on almost all of their wines. "We're growing it; they know that and respect it," George and Judy's son, George IV, says. "We did it right." Though George III is the winemaker now, the Motels are training George IV, a senior at Quinnipiac University, while their daughter "keeps them green" with her environmental studies. George IV is considering going on to get a winemaking degree.

The Motels take us around the vineyard, which has only a few trees. "Trees contribute to frost damage," George IV points out. They cover the *vinifera* soil in the fall and winter just to make sure, although their westerly sloped hills allow afternoon sun and less air flow, causing frost to roll off the hill. Barn cats hunt the yard near chickens and hay while we walk, and George checks the weather station. They do not need to irrigate and barely use insecticide or herbicide. The vine trunks are staggered in a trellis system, letting air flow more freely, and we can see they have trimmed to allow more sunlight to the grapes. "You can't make good wine from bad grapes, but you can make bad wine from good grapes," says George III, laughing.

Their winemaking facilities have nearly outgrown their barn. A year ago, they invested in a bottling machine and now can bottle eighteen

Newcomers George and Judy Motel quickly acquired a reputation by focusing on appellation wines. *Courtesy of the authors.*

hundred in an hour. We see some American and some French barrels. Their production room is kept energy efficient and, perhaps more importantly, immaculate. "Cleanliness is crucial to winemaking. Don't cut any corners," says George IV. Unlike many other wineries, their space for events is small so far. "We want to be able to control what we're doing," Judy says, indicating that later they might build a larger facility. "We can keep a handle on it [the winemaking]. You don't want to be so much you're not anything."

Nevertheless, there is room to grow their brand. By 2010, Sunset Meadows had planted fourteen grape varieties, including *vinifera* like riesling and cabernet franc and promising hybrids like frontenac and chardonel. Their merlot has done so well that they are delighted they could make an estate-bottled merlot. "If we grow it in the correct way, then it'll be a good local product and the wine will speak for itself," says George IV. But the extra effort is a serious consideration for any business owner. Is the appellation worth the trouble?

The Motels are not the only vintners to take the idea of appellation seriously. Down the road in New Hartford, James Jerram started planting in 1982 as a hobby and went commercial in 1998. At the nineteenth-century carriage house that serves as the winery, James has made some of the most popular wine in the state. Though he has kept his vineyards small, he is able to give two of his wines, seyval blanc and marechal foch, the Western Connecticut Highlands designation. The seyval is clean and crisp, with the acid to take a heavy meal, and the foch has more cherry in it than others we've tasted. His other wines are excellent, including the White Frost, a dry chardonnay with just the right butter and oak notes. But with only a few acres, Jerram must bring in some of that chardonnay. "We would love to grow all the grapes," James's daughter-in-law, Cindy, tells us. "By keeping production small we can get closer."

Mark and Lisa Liano of the new Northwinds Vineyard have taken this maxim even further. Though the same size as Jerram, they keep production at fewer than four hundred cases and are thus able to put Western Connecticut Highlands on all but one of their labels. Furthermore, they estate bottle an astounding 85 percent of their wines. Their farm in Watertown had been used for over fifty years as a corn- and hayfield and now grows riesling, traminette, vidal blanc, st. croix and cabernet franc. They try for an organic, sustainable approach to pest management. "Great wines begin in the vineyard," the Lianos say. Their philosophy seems to be paying dividends in the quality of the wine. Their Estate-Bottled Vidal Blanc and Traminette wines both have wonderful floral notes found nowhere else. Their riesling and cabernet franc are classics of their kind, bringing out the best of Connecticut's climate. And their use of botrytis, or "noble rot," to make their Late Harvest Vignoles gives this sweet wine a peachy flavor that bodes well for the use of this ancient process in Connecticut.

This focus on quality rather than quantity may not always make short-term monetary sense, though it shows long-term business thinking. For committed hobbyists and enthusiasts, however, it is the highest goal. Jim Frey, the winemaker at the tiny new Walker Road Vineyards in Woodbury, harvests local st. croix grapes from Woodbury and nearby Watertown. He is able to get 70 percent of them for his Red Table Wine this way and brings the other 30 percent in. This is not enough to put Western Connecticut Highlands on the label, but it is an excellent indication for the future. If small wineries like Jerram, Walker Road and Northwinds could buy more grapes from local growers, this trend would increase and improve.

Meanwhile, larger vineyards like Connecticut Valley Winery can work toward that goal as well. Tony and Judith Ferraro have two vineyards, one at the tasting room in New Hartford and one nearby in Harwinton, for a total of almost thirty acres. For a decade, they have pursued this dream, despite Tony's "side job" as a dentist. Their tasting room is warm and woody, with a large fireplace, black latticed chairs and parlor tables. Just outside of Torrington on the major thruway of Route 202, their winery is always busy when we stop by, and today is no exception.

At the bar, Judith tells us that even though they are only required by law to include 25 percent of their own grapes, they're proud that all of their wines have between 50 and 100 percent. The greatest challenge is not the cold weather but its changeability, which makes it tough "to get your wines the same every year," she says. They plant nineteen varieties, including chardonel and the rare orange muscat, which produces a wine with hints of orange blossom, lemon and honey. They also produce a chianti blend, which reflects their Italian heritage, using seven grapes, including sangiovese, to produce a fruity wine with clove and vanilla notes.

Connecticut Valley's estate-bottled wines include one called Deep Purple, made with chambourcin grapes, and Dolce Vita, a sweet white blend. They have also pioneered the use of the frontenac grape in Connecticut for their Midnight wine, both appellation and estate bottled, with a cranberry nose and a mocha finish. "It grows well in the area, and it's great for making port," says Judith, indicating their Black Bear Port, made with 25 percent brandy. It was named for the bear that invaded the frontenac plot in Harwinton one year, "harvesting" it all for himself. Incidents like that remind us that unless Connecticut Valley could purchase more frontenac grapes from a nearby vineyard that year, they could not put Western Connecticut Highlands on the bottle and, of course, could not call it estate bottled.

Along with more grape growers, the other element that many feel is necessary is a quality alliance. Bill Hopkins and Nick Smith of Stonington would like to see something like Canada's system, the Vintners' Quality Alliance, which does significant assessments on the wine. "We'll be a force to be reckoned with," says Nick. Jamie Jones, president of the Connecticut Vineyard and Winery Association, asks, "Why wouldn't you strive for quality control?" That may be in the future, but first Connecticut needs more acreage and more dedicated vintners like the Motels. "It takes a real commitment," says Judy. In just two years, they've doubled their customers, and they don't want to run out of wine.

This land was not in their family for centuries, but they will pass on their legacy, and that's important. "I was here since we put in vine one. It becomes part of you," says George IV. With this next generation of winemakers, the knowledge will deepen and the dedication will hopefully double. For the Motels and others like them, that means using their own grapes as much as possible. The problem with this beautiful idea right now is that there is greater demand from thirsty customers than they can supply. "We need a larger network of growers," says George IV. Perhaps in the twenty-first century more farmers faced with selling their land will keep it for grapes. As more and more vineyards grow on these hills, more and more vintners will be able to make appellation wine. The larger wineries will make more estate-bottled wine. And Connecticut will be taken even more seriously in the wider world of wine.

12

THE BUSINESS OF THE VINE

Cornstalks sway in the late morning sun as we travel from Foxwoods Casino through Ledyard. Shrewville Road curves frequently, and we pass a farm cart signing "Peaches—$1 a bag." We turn onto Route 1, and the ocean makes its presence known with the flattening horizon and salt marsh air. The dusty dirt road scrolls through the high reeds of the marsh before ending, but vines traipse right to the inlet waters. Red-winged blackbirds survey the foliage, and egrets sweep in white across the waters. Nesting, a family of ospreys guards its gnarled yet comfortable conglomerate of branches, a few hundred feet from the entrance to Saltwater Farm Vineyard.

That the vineyard is set on this beautiful, keyhole-shaped peninsula along Wequetequock Cove is only part of the appeal of this extraordinary winery. What enhances the view is the rounded roof and sprawling space of the converted airplane hangar. From the outside, the building maintains its industrial, unadorned character, but inside the exquisite open floor plan and sleek wood design make for one of the most visually rewarding sights on the Wine Trail.

Site selection, especially given the potential difficulties of growing grapes in Connecticut, is paramount when planning a winery, and Michael Connery took advantage of the beauty and uniqueness of this spot when he purchased the 108-acre plot in 2001. This land had been used for farming as far back as 1653, when Walter Palmer developed it. Farming continued into the twentieth century, and the 1930s saw an airport, built by William J. Foster, begin operation. Closed during World War II, the airport was reopened in 1946 by Henry R. Palmer Jr., operated commercial flights for a few years

and later became a private airport. Long dormant when Michael and his wife, Merrily, spotted it, the hangar has since been meticulously restored. Steven Lloyd took on the architectural challenge in 2006 to showcase and update the original characteristics. A vaulted ceiling provides an inviting openness to the venue, and "original wood sheathing" and "massive timber trusses" tower above the interior.

We ascend the staircase to the tasting room, which overlooks the main expanse of the hangar. Strolling the adjacent terrace, we peer out past the vines to the inlet as the humid salt air fills our lungs. Swallows fly over the vines, snatching mosquitoes from the air. Back inside, manager Paul Peloquin joins us in the tasting room, and we chat over glasses of wine. Sauvignon blanc has a light lemon nose and tart middle with a crisp fruit taste. We compare two vintages of chardonnay, the first also with lemon but finishing smooth with a hint of butter. "I think people underestimate chardonnay," Michael says when he joins us. He "rejects the Australian model" of oaking everything and prefers to keep it in tanks. Our second sample is crisper, with a little more fruit and also more acidity, perfect for food.

The winery has only been open to the public since April 2010, though it has been hosting events for the past three years while the wines matured.

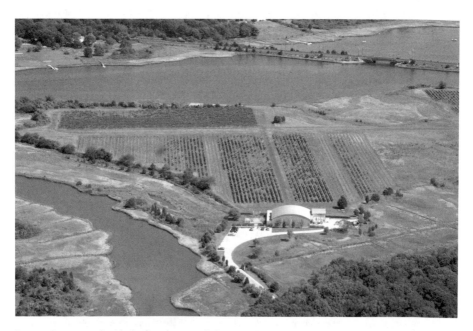

Located on a peninsula in Stonington, Saltwater Farm Vineyard benefits from the moderating influence of Long Island Sound. *Courtesy of Saltwater Farm Vineyard.*

Brides no doubt salivate over the possibilities, and weddings are an important component of growing the business. But Paul quickly acknowledges, "You can be serious about grapes and entertainment. But you must be serious about grapes." Michael agrees, "I'd like to concentrate on the wine, to improve and progress."

The period between 1995 and 2005 saw the number of Connecticut wineries take off, rising to twenty-three. With thirty-one now linked through the Passport Program by 2010, and more on the horizon, expansion continues. More vineyards means more state-grown grapes, and this, in the long term, helps wineries in operation and those trying to get started. "Surely the goal should be to encourage other local landowners and farmers to grow grapes to make up the shortfall," writer Bob Chaplin testifies. Supplying vineyards have already sprung up in places like Brooklyn and New Preston.

Growing more grapes is one thing, but the rigors of beginning a winery are on an entirely different scale. Turning ambitious dreams into reality is a tough, backbreaking endeavor that cannot be underestimated. Even the most successful owners in Connecticut are quick to acknowledge that the often over-romanticized undertaking requires a real commitment, not to mention the even tougher financial decisions like whether to take out a second mortgage or turn land over to developers. An old joke asks, "How do you make a small fortune in the wine business?" The punch line—"Start with a large fortune"—drives home the point of the awesome effort of starting a winery.

When it works, the victory is personal for owners and winemakers. But in commercial winemaking, the public is also the benefactor. When it doesn't work, however, not only do investors suffer but also the industry as a whole is affected. Milford writer Marie Dallas recalls one unsavory trip to a winery that is, luckily, no longer in operation.

Out for a spring drive, Marie and her husband, Don, decided to take an impromptu turn toward Coventry and follow winery signs down narrow country roads. "The newly green trees seemed almost neon when the sun caught their leaves," she recalled. Soon they came upon grapevines, abandoned equipment and a run-down barnlike building amidst an unweeded garden. No one was there to greet them or even affirm that this was, in fact, a winery open to the public.

Reluctantly, Marie and Don forged ahead to the handwritten "Open" sign. Unlocked, the door squeaked, "calling Halloween haunted houses to mind." After calling out, the two perplexed visitors saw a disheveled man slowly descend into the cluttered room. Acting with the false hospitality of

someone trying too hard, he explained that he's owned the vineyards since 1968. From then on, they watched as with each pour their host "added a generous swig" to his own large cup. Uncomfortable until the end, Marie and Don left with three bottles, perhaps the only way they could make a clean getaway. Don remarked, "I was afraid he'd come after us with a shotgun if we didn't buy enough!"

Such experiences tell us why this winery is no longer in business. Commercial wineries are in business for us, and if customers aren't happy, the venture is doomed to fail. But luckily the best models exist, and successful Connecticut operations offer inspiration and assistance about how to do it right. Sharpe Hill's Howard Bursen is not only a premier winemaker but also an expert consultant on starting and designing a winery. As the success of Sharpe Hill attests, Howard's experience and insight can be valuable for first timers and those looking to improve. Most importantly, a sound business strategy must be in place before beginning the lengthy process. With astute pre-planning, neophyte owners can assess preparation costs, decide on grape varietals, design trellis systems and plot fields for manageable growing densities. Terrain that has been previously farmed offers prime soil, but other, more subtle characteristics of the potential grounds should be considered, like disease incidence, optimum temperatures and potential for expansion.

A mission statement can be useful. One of the first things Linda and Dick Auger of Taylor Brooke did was articulate a philosophy and pinpoint their direction. "We had a mission statement from day one," Linda tells us. "I encourage other wineries that are just starting up to think about who you want to be." Once philosophical foundations are in place, the actual construction of the winery is considered. "The sky is the limit when it comes to costing winery buildings," Howard Bursen explains. "Those intrepid spirits who have strong wills…have done well adapting an existing building," as Michael Connery did with Saltwater Farm. Working with something that is already in place can be a way of preserving the past. Building from the ground up can be equally satisfying. Either way, the structure will inevitably show off each owner's aesthetic vision.

Of course, owners must decide which grapes to grow. Spreading risk among a number of varieties makes better sense and helps to explain why most growers try to grow more than one type of grape. Crosswoods Vineyard, for example, failed in part because owners decided to plant one variety and produce one wine. Indeed, as Gary Crump explains, failures of some grapes, both *vinifera* and hybrids, are economic failures, not necessarily failures of the plants themselves.

Russell Holmberg chose to plant these pinot blanc vines due to their similarities with chardonnay. *Courtesy of the authors.*

The list continues with equipment. Tanks and barrels are obvious, but even the simplest choices can be daunting and require not only price considerations but production assessment as well. State-of-the-art bottling machines "cost more than my college education," laughs Jamie Jones. "A labeling machine's costs," advises Howard Bursen, "starts with a glue pot and a manual roller for about fifty dollars to a blindingly fast automatic labeler costing more than many a small winery." With these mammoth deliberations, not to mention piles of regulation and legal paperwork that must be dealt with, it takes not only acute business sense but also nerves of steel. Planted vines do not result in wine right away, and once they do, necessary experimentation and tinkering is needed before wines are even close to being ready for mass production. Saltwater Farm began planting nearly ten years before its winery doors opened.

Another option is to take over an established winery, which also incurs challenges. When Courtney and Amy Brown purchased Haight Vineyard in 2008, Sherman's vines had fallen away somewhat since he put the property up for sale three years earlier. The Browns focused on revitalizing the twenty-

five acres and improving the tasting room. They also had to contend with a damaged reputation but have worked hard, with the help of winery manager Tina Torizzo, to "establish a winery as a comfortable gathering place that will appeal to a wide range of tastes." Courtney's family has a rich history in farming, and Amy's corporate background makes for a good match. Sherman Haight himself helped with the transition and occasionally stops in for a glass. With new plantings and activities such as winery bike tours and gallery exhibits, the Browns are putting their own stamp on the historic winery. Since they still have forty-year-old vines of marechal foch and de chaunac, some of the oldest in the state, they have one definite advantage.

We are reminded of the obstacles that all wineries, new and old, must contend with as we sip Saltwater Farm's Merlot. The Connerys' business plan was clearly in place as they tested the soil early on and hired French winemaker Giles Martin, who had extensive experience on Long Island. "It's an area where you really shouldn't cut corners," says Michael. Like Long Island, Saltwater benefits from the ocean's influence. Here, the grapes, particularly merlot, have "a little more hang time." But even an ideal ocean spot is subject to cold snaps that kill many *vinifera* vines in New England. They lost 90 percent of the vines and were forced to replant after the bay froze up completely.

Equally impressive, both versions of merlot that we taste bear the AVA mark of "Southeastern New England." The first is a wonderful dark ruby color with a vanilla nose and lots of plum on the palate, with notes of smoky pepper in the middle and satisfying tannins. The second brings more fruit to the front, is velvety and balanced and has a little more bite to the end. It's impossible to say if one is better, but to do so would miss the point. We are extraordinarily lucky to taste both.

New wineries like Northwinds, Walker Road, Cassidy Hill and all those on the horizon have their work cut out for them, but the owners know that. No one ventures into running a winery without serious financial and mental resources. Whether dealing with leaf hoppers, persistent fungus, thieving black bears or freezing inlets, they have the courage to keep going, season after season. Judith Ferraro of Connecticut Valley Winery sums it up perfectly: "If the people standing in front of us like it, we're in business." But "it" means the whole experience, from pulling into the driveway to browsing in the fields. Standing at the tasting bar, we want to speak with knowledgeable people who know what they are talking about and love what they are doing. And we want to taste a quality product. That's when we fill our cars and return again and again.

13

RHUBARB, RUSSETS AND RASPBERRIES

With magenta arms dripping with juice, Eric Gorman dumps a pile of fresh black currants into a manual crusher. The teeth of the crusher churn, their sharp points grinding and separating the smashed berries. About a week after crushing, he'll press. We taste the currants, finding them juicy and tart with a hint of cinnamon. The wine made from them, in our hands, is a surprisingly dry red. Connecticut is the largest producer of black currants in the United States, and making wine from them is as old as America. As Connecticut luminary Colin McEnroe has stated, "Not everything that is called wine is made out of grapes."

We are in the new commercial kitchen at White Silo Winery in Sherman. The temperature is naturally kept a perfect constant in the basement of this huge, ancient barn, once part of the Upland Pastures Dairy Farm. The original family still lives in the farmhouse on the hill; they're happy the Gormans have kept the land a working farm. "The soil is fertile," Eric says—an understatement no doubt. Next to the new kitchen is the old calving room, which dates back to 1800. Though it's filled with hay and cornstalks for insulation, the original whitewash shows through. Today, we watch a birth of a different kind as Eric starts the process of turning fruit into wine.

His father, Ralph, comes into the kitchen, mustache and craggy face breaking into a smile of greeting. He lifts a bottle of rhubarb wine "that people mistake for pinot grigio," he says. In fact, he got the recipe from Cornell's famous agricultural program and modified it. Afterward, the farmers at Cornell asked, "How did you get the rhubarb so clear?" and came to Ralph for advice instead. Ralph shares an anecdote about a chef

who hated fruit wines but told him his pinot grigio was good. It was actually the rhubarb. "We got it right," Eric says.

Ralph started winemaking with $1,000 as a hobby at the pick-your-own raspberry and blackberry farm. People told him, "You're crazy, you can't do this." But he was "ready for a new challenge." Ralph prefers very dry wines but knows that customers might not. They use a hydrometer to get it just right, measuring sugar levels. Eric says he had a tough time understanding the chemistry behind winemaking, and his father's brilliance and background as a physics professor helped. But Eric has brought a precise, computerized regularity to his father's alchemical genius. Each lot is precisely calculated and tracked for brix and alcohol. He shows us his spreadsheet, noting when each batch is pressed, when yeast is added, when it's fully fermented, when sulfates were added and when it was transferred from one tank to another, all sorted by number. "It's run as a business," he says.

Eric does this despite his "other full-time job" in Manhattan. Of course, he doesn't expect to make nearly as much money as he would in corporate life. But now that Ralph has had his "hurrah," Eric wants to continue the work and keep the farm in his family. Winemaking is an "extra layer of labor on what is already labor intensive." The double life leaves him "exhausted—but in a good way." Despite this, he has made improvements to the process. Ralph had been cutting rhubarb with a paper-cutting machine. Since they need ten thousand pounds of rhubarb for their wine production, about one pound per bottle, they invested in a robotic crusher. They're also experimenting with yeasts, currently using a fairly aggressive one. With fruit wine, Eric feels that winemaking techniques become more important, not less. "Cleanliness is key." They age their fruit wines, but only to clarify them. The exception is black currant, which ages well in the vat and even better in the bottle.

"We have to reeducate consumers who say this is not wine," says Eric. That distinction is historically recent. During colonial times, imported wine was only available in cities and at the most popular taverns. Locals always made their own, from whatever fruit was available, because it was cheaper to do so. Sometimes that meant wild grapes but also strawberries, raspberries and currants, which were plentiful. Later, when apples were cultivated in New England on a large scale, they were pressed for cider, which often served as a base for wine or brandy. For example, the town of Torrington boasted four cider mills and one brandy still in 1774. A typical beverage at a wedding feast, tankards of spiced cider were passed around after the ceremony. Ungrafted, the trees produced sturdy, bitter fruit that would have been unappealing to eat. In addition to fruit, other herbs and greens, like

burnet leaves or clary flowers, could be used to make wine. Wine was served to children and at adolescent parties. Hard cider, though low in alcohol, was drunk at every meal by both rich and poor.

Despite the rich history of fruit wine in Connecticut, even White Silo has planted rows of cayuga, marquette and frontenac grapes. Eric sees them as a challenge and as something to give customers a wider range of selections. "We're intrigued by it only to expand the business." Until the vines are ready, they're experimenting with making a dry cayuga from purchased grapes. "Somebody came to us the other day and asked us to distill," Eric says. "We're going down this road. We don't know where it's leading us."

Meanwhile, their fruit wine continues to surprise. The Rhubarb is crisp and light, without a heavy fruit flavor. In years past, we bought bottles of their Blackberry, a full-bodied wine that we drank with meals. They combine to make a tasting room special "sangria," without any extra fruit like the orange slices or strawberries typically added. Diana at the tasting counter says, "I pick the fruit, I touch the earth, so I can speak about it with sincerity. It brings simple pleasure. We can taste the land."

Eric points to others in the "nice community of Connecticut winemakers" who have made great fruit wine, including pioneer Dr. Paul DiGrazia,

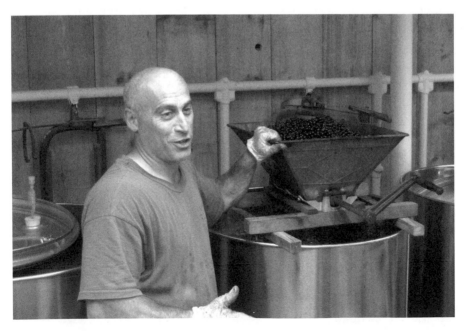

Eric Gorman of White Silo Winery works hard at two jobs "to keep this farm in our family." *Courtesy of the authors.*

just a few miles down the Housatonic River. DiGrazia makes interesting combination fruit wines like Autumn Spice, a mix of honey, sugar and pumpkin. "This is Thanksgiving," said a taster trying it at the recent Connecticut Wine Festival. But DiGrazia's focus, as usual, is on health, and he created his Wild Blue for that purpose. Made with blueberries, each bottle contains sixty-two hundred milligrams of phenolics, a type of antioxidant found in skins and seeds. "It's more than how food tastes," DiGrazia says. "Americans are concerned about health. You need to look for what consumers want, not what your ego wants to make."

Farther down the Housatonic Valley, Jones Farm has been making great fruit wine since a scientist from the Connecticut Agricultural Experiment Station suggested it to Jamie Jones. While his grapevines were growing into maturity, he crafted dessert wines, like Strawberry Serenade—tart, bubbly and sweet. With Black Currant Bouquet, he created a dessert wine, sweet and tart almost in excess, an explosion of sensations. Finally, made from apples, black currants and the pears from Bishop's Orchards, First Blush was an acidic wine with a fruity nose to go with food. This hugely popular fruit wine still "pays the bills" for Jones.

Connecticut Valley makes peach and raspberry wine. Haight-Brown brews an apple wine flavored with cranberry. Land of Nod features semisweet raspberry and a raspberry-blueberry medley. Some use fruit infusions with grape wines, like the Augers of Taylor Brooke. Linda Auger recognizes there's stigma with fruit wine. She tries to educate her customers, some of whom think that their wines are fruit wines or don't want to go to a winery that doesn't grow grapes. "Ninety-nine out of a hundred say it's because they're too sweet." She tries to explain, "It doesn't have to be; that's the choice of the winemaker." Their Chocolate Essence, an infused merlot port, is certainly a dessert all by itself, but their infused Green Apple Riesling wine is acidic and balanced.

At Bishop's Orchards, Keith Bishop started with farmhouse-style cider and began fermenting it into wine in 2005. Keith hired consultants and began fermenting cider into several apple wines, infusing them alternately with spice, pear and cranberry. They increased quickly, doubling and then tripling the number of fruit wines, experimenting by using the fruit frozen on the trees to make wines with an intense sugary bite. Their Crimson Rosé, a smooth and tangy strawberry-raspberry mix, is perfect as an aperitif.

Russell Holmberg at Holmberg Orchards puts it most succinctly: "In order to make fruit wines, you have to be able to make grape wine." They already have equipment in excess to what many wineries have: bigger filters, pressers and carbonation machines. When Russell came back from

the University of Connecticut, he was interested in expanding his family business, and like Bishop's Orchard, he started with cider. "We didn't have grapes but had plenty of apples." His father, Richard, had planted different varieties, including a unique variety of golden russets, now called Holmberg russets. Like many wine grapes, these acidic, tannic apples are unsuited for eating but perfect for fermenting into alcohol.

We try Holmberg's Macintosh Apple Cider, which is not sweet but bubbly, with a nose similar to a sauvignon blanc, a middle with a hint of cinnamon and spice and a finish like a blend of chardonnay, vignoles and vidal we once tried. Their apple wine is dry and smooth, and only their World Peach wine has any real sweetness. Russell tell us that the perception people hold is that fruit wines will be like "Boone's Farm"–flavored drinks. "People with a more exploratory or refined palate who know and appreciate wine always receive it very well and are rewarded," he says.

But Russell has started another project that has garnered national attention. While at the University of Connecticut, he met Margaret Chatey of Westford Hill Distillery, "a mentor and inspiration." She was interested in a fascinating Old World technique called "hanging glass," or placing Italian glass bottles around the young pears near the trunk of the tree. The pears then grow inside the bottles throughout the summer. The glasses are cut down in August, and after cleaning them, pear brandy is added to the bottle. Russell volunteered to try it on Holmberg's Bartlett pear trees. "When a bud breaks on a pear blossom, early in the season, we select the biggest of the cluster that comes out and slide on the bottle." On the tree the bottles look strangely beautiful, like they belong there, a strange partnership of glass and fruit. When the pears are ready, Russell cuts them down, sends them to the Chateys and Westford Hill's Poire Prisonière pear brandy fills the bottles.

Driving up idyllic Chatey Road on the way to Westford Hill Distillery, we spot mulberry trees, leftover from the long-ago silk industry boom in Connecticut. It's a reminder of agricultural changes but doesn't make it any easier to believe that this is the only commercial distillery in a state that once held hundreds. The road is named for the family, starting with Louis's Hungarian grandparents, who came to Ashford in 1919, bought this farm and raised chickens, pigs and cattle. Distillation took place on the farm, illegally at that time, the results hidden in an old chestnut that was hollowed out underneath as a "smuggler's tree." Before Prohibition, apple brandy was hugely popular in America, and Louis Chatey reminds us that "Johnny Appleseed planted for brandy." Now brandy is being made here again—true brandy distilled from pure fruit with no sugar added.

In the 1980s, Louis and Margaret began by planting grapes on their two-hundred-acre farm, taking plantings of chardonnay, riesling and seyval from nearby Hamlet Hill Vineyards. But their interest in "fruit spirits" grew when they encountered them in Europe, and they decided that distilling was their true calling. "We felt that with all the fruit in New England, no one was doing anything like this," Margaret says. Eau-de-vie, "water of life," is essentially a clear brandy made from fruit—a palate cleanser, *digestif*, often used in cooking. In 1995, the Chateys built their distillery in the old barn, and four years later they created their first commercial batch.

Louis guides us into what looks identical to many wineries we've visited, and in fact the first step of distillation is nearly identical to winemaking. Louis shows us where they hand sort the fruit, the hammer mill and the huge fifteen-hundred-gallon tanks. "There are more steps involved. Less difficult in that we don't have to do any acid adjustments. We don't use chaptalization; there's no filtration to bring out a finished wine. The extra step is the distillation, aging, then after aging we have to run a filtration," he says. For cherry kirsch and apple and pear eau-de-vie, the Chateys add wine yeast to begin fermentation and watch carefully for the next month. In the early years, they experimented with different varieties of fruit and had to find the right types of barrels. "We don't use any new oak because that would overpower the delicacy that we want to get out of the fruit," Louis says. For some, they use two-year-old, medium-toast, white wine barrels and rotate them, achieving a perfect balance of flavors only after five years of work. "Every batch is different, and you have to evaluate as you go."

One difference is that they cold ferment everything at sixty degrees, except for strawberry and raspberry, which are even lower. This would kill wine. The barn is not heated or cooled, so the oak barrels expand and contract, releasing alcohol that drifts up toward the ceiling, called "the angel's share." Louis points out that most home distillers cut corners in this process. "It's really critical to produce a really fine base wine." And of course, they must take the fermented fruit product, not quite wine, and distill it, a process that takes place in the adjoining room, in their beautiful Arnold Holstein.

When the Chateys started this business in the 1990s, Arnold Holstein stills were rare in America, and this remains the only one in Connecticut. Designed to hold aromatics, this handmade Bavarian device is a pot still with a condensing tower, a rising column punctuated at intervals with port holes. The fruit mash is pumped into this still, which concentrates and separates methyl and ethyl alcohol by boiling and forcing vapors up the tower. They are careful to not go "too low" with the alcohol and turn the flavorful spirits

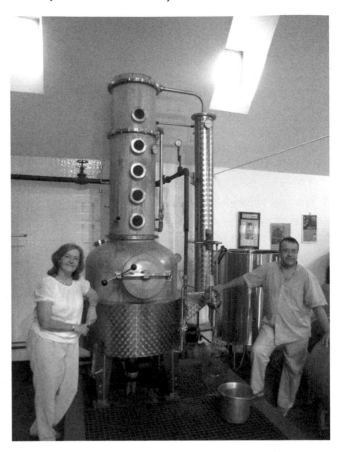

When Margaret and
Louis Chatey began
making eau-de-vie,
a handmade Arnold
Holstein still was
nearly unattainable,
and it remains unique
in Connecticut.
Courtesy of the authors.

neutral, like vodka or grappa. "In eau-de-vie, the fruit is very present in terms of aroma and flavor," Margaret says. Everything comes out of the still at 180 proof; spring water off the property is added to adjust to standard proofs. The resulting liquid is chilled and run through a plate filter, emerging clearer than water.

Near this amazing still, two women, Debbie and Cathy, sit at a table, wrapping fabric labels around bottles in a way impossible for a machine to reproduce. Cathy White is the distiller, with a degree from the University of Vermont. Sue Rollins, an artist from North Haven, does the labels. The bottles are imported Italian glass, with hand-dipped wax tops, also impossible to be applied with a machine. "We wanted to emphasize that the product is hand distilled; we wanted the bottle to look that way," Margaret says.

Here we also get to see the end result of the bottled pears on the trees of Holmberg Orchards. The beautiful curve of the Poire Prisonière won best

of show out of thirty-five hundred entries in packaging design at the Los Angeles International Wine and Spirits Competition, as well as other gold and silver medals. Margaret tells us the secret of its success: "What Russell knew, that perhaps somebody else didn't, is that when the clusters form, there's usually five pears per cluster at infancy. One of which is the bull pear, and you have to be able to identify which is the bull pear and put that up into the bottle. And care for it through the growing season, through windstorms and kids with BB guns."

On the patio of Louis and Margaret's amazing eighteenth-century Cape, we share lunch and eau-de-vie while discussing the changing tastes of Americans. Their Airedale sleeps in the sun nearby. "This is how we were introduced to eau-de-vie," says Margaret. "On the back porch." The kirsch is our favorite of the clear eaux, but the ten-year-old apple brandy is a revelation. Made from a blend of five different Connecticut apples from Middlefield's Lyman Orchards and aged in American and French oak, it defeats the finest calvados we've tasted, with fantastic vanilla and butterscotch notes.

Though critics and chefs have lauded their products, the Chateys are humble. "We started twelve years ago and nobody knew about this. Now, twelve years later, next to nobody knows about it," Louis laughs. We can only hope that changes. This rebirth of an ancient industry here in Connecticut reminds us of all the amazing things we can do with our fruit. It makes us wonder how stigmas are born, how popular opinion turns on misinformation and whim. In 2010, though, there is a trend in California to make fruit wine, including rhubarb, and no doubt it will spread. "Fruit wine is the country's oldest drink," says Russell Holmberg. And of course, one of those fruits is the grape.

14

ON THE TRAIL OF TASTE

W hite lettering reflects against the blue metal of the sign, and arrows point the way to the next vineyard. Visitors venture out into the maze of highways and back roads that lead, one after the other, to vines and wine. Even with Connecticut's small size and the growing number of wineries, the connections between stops are often long and twisting. But half the fun, of course, is getting there through rising hills, past weathered stone walls and along the ocean's lip.

Even in the early days of Connecticut's wineries, when only a handful were open to the public, pioneers like Sherman Haight foresaw the potential benefits of a linked system to help sightseers travel between wineries. The idea of winemaking in the state was novel to begin with, so winery owners certainly needed all the help they could get promoting and encouraging visits. Perseverance paid off when Haight, Bill Hopkins and Paul DiGrazia persuaded officials like the state's first female lieutenant governor, Eunice Groark. "The governor could see…the value of promoting the state's agriculture," said Bill of Lowell Weicker, who dedicated the Connecticut Wine Trail in 1992.

Now run by the Connecticut Vineyard and Winery Association, the Wine Trail connects the vineyards in the Litchfield Hills to those along the coast and up into the Quiet Corner. Signs touting "Connecticut Grown" point the way to a network of wineries and also highlight local orchards, nurseries, tree farms, dairy and livestock farms, sugar houses, docking fishing boats and farm stands. In addition, the Connecticut Farm Winery Development Council of the Department of Agriculture developed the Passport Program to promote wineries and increase visits. The little blue booklet shows off

each winery's stamp, has space for notes and offers a great incentive to visit at least half of the wineries: weeklong vacations to Spain and weekend getaways in our home state.

Even after Barbara and Rick Warga from New Preston took their winning two-week trip to Spain in 2008, they still enjoy coming back to Jonathan Edwards, their "home winery." Barbara explains the draw of the Passport System: "We had more fun doing the Wine Trail. It's a social event. Bars are for young people, wineries are for adults." Meeting people is definitely their favorite aspect of the trail, and Barbara notes there are added benefits: "Your taste is literally going to change from day to day."

There are many motivations to keep such a system thriving. For every one dollar spent on tourism, a typical sightseer leaves eight dollars behind. Nick Smith of Stonington Vineyards estimates his own winery attracts forty-two to forty-five thousand visitors a year. He says winery workers should "hold our heads up high" considering how much they contribute to tourism and "lifestyle investment."

Linda Auger of Taylor Brooke Winery agrees. The beauty of this type of program is that it "helps to send people to other parts of the state that they probably haven't seen before." Local economies benefit when people have to buy gas, eat and shop. "There is a ton to do," she reminds us. "You don't have to go far. We're not that big a state." Wine tourism offers escape, adventure and ample opportunities to combine wine tasting with other activities, outside or in, like camping, hiking, antiquing or gaming.

The Wine Trail and Passport Program offer opportunities to try the latest vintages at our favorite or hometown winery, enjoy music and food at one of the many festivals and expand our route and visit new tasting rooms. Even with its five acres of planted vines visible from behind the stone wall, Savino Vineyards blends into the suburban landscape of Woodbridge. But that's exactly what Gerraro Savino wanted when he decided to plant vines in his backyard. Jerry, as he has come to be known, left Salerno, Italy, in 1954 and came to the United States to work in the restaurant business, eventually settling in Woodbridge in 1971. Retirement gave him the opportunity to finally plant his dream.

The small red building at the end of a gravel drive looks more like a shed than a tasting room, and when we drive up on Independence Day, only one other couple has decided to brave the July heat. Sonia, Jerry's daughter-in-law, greets us inside, and we sit at the bar on comfortable stools. A few round tables with chairs fill out the room, and the walls smile with harvest pictures and family portraits. Passports await travelers in a neat stack. Behind the bar, an antique cash register still functions.

Tasting signs like this at Savino Vineyards in Woodbridge invite visitors to the unexpected. *Courtesy of the authors.*

While a crowded tasting room with lots of suntanned sippers may encourage owners, there is something about the privacy and attention of a quiet tasting. We have the chance to relax and chat with Sonia about the winery's short history and Jerry's plans for the future. We take our time alternating between slices of pepperoni, Parmesan cheese and wheat crackers and glasses of seyval blanc, merlot and st. croix. Offering snacks with the tasting was the idea of Jerry's wife, Louise, who passed away in 2009, only a year after their opening. While wine crackers are the usual staple, they can be a little sweet, and these slightly salted crackers do the job of neutralizing the palate between sips, especially when moving from one wine to the next. Starch also works to soak up some of the alcohol and counteract the effect of tannins.

One of the many benefits of the tasting room experience is being able to pair vintages. Savino's 2007 Merlot is dark plum in color and provides wonderful hints of berry on the nose, as well as cherry and vanilla. Smooth and evenly balanced, the middle gives off more fruit, with a light earthiness and a little pepper on the finish—satisfying through each sip of the tasting

and excellent with a bit of Parmesan. On the other hand, the 2008 Merlot has a much different brick color, more typical of what one would expect from a merlot—earthier on the nose, with much less berry than the first. More spice and pepper come up front on the first sip, while an even, velvety smoothness of smoky berry fills out each swallow. The second is more tannic, slightly more full-bodied. Of course, with so many variables from year to year—60 percent of the grapes are grown on the vineyard, while the other 40 percent comes from California—it is no surprise the two would be so different.

Whether they are intimate or grand, tasting rooms are the best way to experience Connecticut wine, but the experiences can vary from a quick stop to get a passport stamped to a leisurely afternoon spent under festival umbrellas to a sunset concert on a fall evening. We pull into the long grape-bordered driveway that leads straight to the Chamard Vineyards tasting room. Chamard lost its vines recently, but baby vines await their time, protective white guards over thin trunks. Fieldstone covers the beautiful building that houses the cellar and tasting room, and the entryway is lined with glassed accolades and numerous "best of" awards, reminding us of Chamard's storied past.

We are here to listen to Grammy-nominated singer-songwriter Lauren Agnelli and enjoy a few sips in the spectacular tasting room. Comfortable, rustic and classy, the room is intimate. Rafters meet in half-wheel spoke configurations at the ceiling's apex. A mighty fireplace frames the room, and a pile of wood awaits a winter day. Through French doors, a small terrace looks out onto more vines, a tent readies for the next event and a pond keeps watch as dusk approaches. Though the evening chill is on, people chat, taste and listen. A group of women hosts a bridal shower. Lauren sings "J'ai Faim Toujours" as the tasting room brightens, bulbs seamlessly taking over when the natural light fades.

Chamard's Chardonnay is in the classic style, gold in color, smooth and even, with a touch of honey on the finish. We drink a glass of 2006 Merlot, dark, almost black in the narrow glass; with light tannins, it is smooth and balanced. The 2005 Cabernet Franc Reserve is also divine, with smoky berry and a little butterscotch. It becomes slightly more peppery as the night goes on and the wine aerates. Lauren and her partner, Matt, join us at the bar, and we ask how performing at a winery differs from her other gigs. "The hours are better," she laughs, "the money is pretty good; the crowds are good. People are into the place and setting, so they're into the music scene more." In the summer, they perform outside, but as the weather cools, the coziness of inside is welcoming. Wineries are increasingly open to new ideas

Singer-songwriter Lauren Agnelli entertains guests in front of the fireplace at Chamard Vineyards. *Courtesy of the authors.*

to draw customers in, and Lauren agrees that Chamard's tasting room helps to create the perfect atmosphere. "It's the kind of room I'd like to have for my own house."

While the vineyard experience cannot be duplicated, customers still rely on traditional outlets to buy wine: liquor stores and restaurants. Increasingly, Connecticut wines are finding a place among the shelves and on menus. We ask owner Bob Feinn of Mount Carmel Wine and Spirits of Hamden—"the finest wine shop in the state of Connecticut," according to Nick Smith of Stonington Vineyard—why they carry Connecticut wines. "One," he says, "you want to support local industry, and two, this is good wine." Concerned about how much fruit is actually from Connecticut, he thinks about percentages as he's choosing wines to carry. He wants to showcase wine made from local grapes. He says of Larry McCulloch, "He is the prime winemaker in Connecticut. He knows the fruit; he knows how to handle it. His wine is most definitely competitive with California." He returns Nick Smith's compliment and says, "Stonington does a good job." Bob and his brother Ben taste every wine and even detect "that northeastern

character" in Sharpe Hill's wine. "I normally prefer the Connecticut wines to Long Island," he says. "They don't have the fruit to stand up to the oak they give it."

On the future of Connecticut wine, he feels encouraged. "They've proven they can do well with *vinifera* grapes, with chardonnay, cabernet franc, riesling and pinot gris…seems to be something people want to work with here." As winemakers know, "it comes down to finances. You know chardonnay is going to work, you know riesling is going to work, you know the hybrids will work. But for cabernet sauvignon to be economically feasible…I think it is a losing proposition."

While it is satisfying to bring a bottle home, we also want to go out to bars or restaurants to experience Connecticut wine. Though the state's winemaking industry is growing, restaurants understandably make space for proven favorites instead of taking a chance on local, less recognizable selections. Some establishments, like Tastings Wine Bar and Bistro in Mystic, carry one or two selections, like Sharpe Hill's Chardonnay, no doubt because it is rated by *Wine Spectator*. However, there is a growing trend as restaurants like the Firebox in Hartford and Skipper's Dock in Stonington showcase Connecticut wines, though only a few appear among the long list. Some wineries like Strawberry Ridge make wines exclusively for restaurants. At West Street Grill in Litchfield, we find Strawberry Ridge's Ascot Reserve, Western Connecticut Highlands appellation. It is green and tart but buttery, with toast rather than oak on the finish, paired well with the coconut pineapple soup, which brings out the creaminess of the wine. Robert and Susan Summer started their vineyard next to Hopkins on Lake Waramaug after years as successful businesspeople. Several exclusive restaurants in New York City began carrying their wines. This led the couple to produce the house wine for Rao's Restaurant in East Harlem. Though many of the wines they produce are from California grapes, their Ascot Reserve Chardonnay, which they have been producing since 1997, is grown on site.

Just off the town green in Guilford Center, Ballou's Coffee, Wine and Chocolate is a superb restaurant supporting Connecticut wines. We sit down to lunch on a breezy June day. Both the terrace and the dining room attract summer tourists; at the table next to us, three generations of women lunch, speaking French and enjoying wine. On the menu is an assortment of fondues, soups and paninis. The offering of wine flights, which give customers the chance to sample three wines from the extensive menu, also intrigues us. Best of all, with fourteen on the menu, we can have a flight of just Connecticut wines. Flights are a perfect way to try

wine in a setting a bit like that of a tasting room, but one that includes the added benefit of food pairings.

After their first restaurant closed, Steve Kaye and his wife, Debbie Ballou, decided to open a European-style wine bar with a depth of worldwide wines and local selections. They spent two years researching gastro pubs, wine bars and cafés in New York, London and Paris. "When we first met with the distributors, they asked us how many wines we wanted to taste, maybe eight or nine? We said that might cover the dessert wines." With over one hundred wines, they started offering selections from three Connecticut wineries and now showcase six. "People have no idea how good Connecticut wine is. Deb and I felt local business should be supported."

The flight arrives on a metal serving tree that allows the glasses to hang in the shape of a bunch of grapes at staggered heights, each carefully numbered to match the menu. We choose two whites, Cayuga White from Gouveia and Traminette from Taylor Brooke; two rosés, William Sonnet Blush Riesling from DiGrazia and Pure Rosé from Jones Family Farm; and two reds, St. Croix from Sharpe Hill and Ripton Red from Jones. Traminette is beautifully floral, with roses on the nose and flowers in the taste, a little sweet, with a thick mouth feel. Cayuga White offers a nose like an outdoor breeze, oranges in the middle and on the finish and is just off dry. William Sonnet Blush is sweet but not syrupy with light red berry notes of strawberry and raspberry, a great summer wine that goes surprisingly well with the cheese fondue. Jones's Pure Rosé is clean and dry, not as sweet as the blush.

A heaping bowl of olives provides just enough brine to accompany our savory horseradish fondue and assorted cured meats. Jones's Ripton Red gives us a warm vanilla nose, with dark berry in the middle and an earthy, truffle finish. St. Croix from Sharpe Hill also has hints of vanilla and caramel and a medium body, well balanced overall with a hint of butterscotch. Steve and Debbie knew what they were doing when they selected these for the menu. "We tried to pick what we felt were the best." We finish with a sample of Jones's Strawberry Serenade, a blend of strawberries and chenin blanc. A sparkling wine, it bubbles lightly with sweetness, like a fruit exploding in your mouth.

Steve acknowledges that there are obstacles for both proprietors and wineries. "Somebody like Connecticut Valley Winery, who we love, can't distribute because they don't make enough." But while that fact may limit accessibility for some of the state's wineries, it should not prevent us from tasting, purchasing and enjoying wine. Outlets for obtaining local wine do expand; shipping out-of-state is possible, and someday soon, we may be able to purchase wine at farmers' markets.

There are practical reasons to taste wine in all these settings, the first of which is the winery itself. We scan crowded shelves, talk with knowledgeable sommeliers and consider price and packaging, but it comes down to individual palates. And there is a more important reason to enter a tasting room: discovery. Since the route is marked, like the yellow bricks that Dorothy followed to the Emerald City, we can easily get to Heritage Trail, Walker Road or Land of Nod. Along the way, we may just take a turn we hadn't anticipated. With a willing heart and the courage to undertake the adventure, we find the tastiest rewards.

15

HARVEST

Clouds bunch in the morning air, and tree swallows clip across the road, disappearing into yellowed trees. We pass two equestrians on the sunny road and wave, heading out of the suburbs and into Connecticut's countryside on a mission. As Jonathan Dickerman said in 1872, "When the golden October sun has colored the vineyard into full display of purple, the leaves cast, and the stems of the cluster turned brown, the owner must have everything in readiness to begin the vintage." In Dickerman's time, and for thousands of years, neighbors anticipated this annual activity and participated with eager hearts. In that neighborly tradition, we are traveling to our local vineyard, Gouveia, to join the reward of harvest.

We drive past the Wallingford Community Gardens and the Mackenzie Reservoir. Nearby, at the end of a cul-de-sac, past stone walls and cedars, Richard Ruggiero is about to open Connecticut's newest winery, Paradise Hills. The Ruggieros have been growing grapes for twenty-five years, first at a vineyard on Paradise Avenue in Hamden. When they moved to a larger farm in Wallingford, they kept the name. Selling most of their grapes to other Connecticut wineries, they kept a few for themselves, entering amateur winemaking contests throughout New England. When their daughters graduated college, they "decided to take the next step" to expand into a commercial winery. "It's a labor of love," says Brenda Ruggiero. They will be inviting guests to a Tuscan-style tasting room and offering a half dozen wines for the public to try, though they grow mostly chardonnay. The winery sits on the historic Washington Trail, for which they have named both red and white blends. "I can't wait until they open," says Dawn Bryson, Gouveia's

office manager. "We're happy they're going to be here because people say, 'Wallingford? One vineyard?' Now we've got two." Soon the Ruggieros will also be inviting people to harvest and to share in what that means.

At the top of nearby Whirlwind Hill, black iron gates open to the long gravel drive of Gouveia Vineyards. Joe and Lucy Gouveia bought this former 140-acre vegetable farm in 1999 with the dream of making wine. Though Joe came to America from a Portuguese village when he was twelve, he remembers clearly what it was like growing up in a culture committed to the grape. "I was always involved in the community. In the village everybody had a vineyard," he says. They opened to the public in 2004 and now are one of the largest vineyard wineries in the state.

That fact is especially evident today as we drive into the fields to begin the harvest. Hundreds of people from all over Connecticut crowd the aisles, pulling grapes off the green-leafed vines to the jolly sounds of strolling accordion players. We take clippers and carefully snip heavy bunches of tart seyval blanc, and soon the rich juice coats our hands and saturates our clothes. Carved owls and hawks flap at the end of strings tied to poles,

Wineries like Gouveia Vineyards encourage you to bring a hat, clippers and friends to pluck bunches of grapes on harvest day. *Courtesy of the authors.*

keeping other birds away from the fresh grapes. Vine by vine, we clear the fields, leaving the smaller, harder grapes for a late harvest in a few weeks. As the hours pass, I haul full crates of grapes to the ends of the rows, where pickup trucks take them back to the destemmer and the huge metal vats below the tasting room.

We are called into lunch by the smell of grills sizzling with steak and chicken. Everyone gathers under a huge tent, talking about their children, exchanging news in Spanish, Italian, Portuguese and English. We talk with Theresa, Joe's niece-in-law, who says, "As an environmentalist, I've tried to eat as local as possible, and now I try to drink as local as possible." She points to families who have come to harvest for years in a row. "People are starting to understand that something's missing in their lives."

Owner and winemaker Joe Gouveia can be spotted by his salt-and-pepper beard and tanned arms, along with a signature baseball cap. One of the first things he tells us is that he is "not a big drinker." Instead, he is in this business for other reasons. He modestly tells us that he is "still learning" how to make wine but talks with great knowledge about his *terroir* and its effect on different grapes. Gouveia is considered one of the warmest vineyards, and the high, lonesome hill relatively near the coast receives a lot of wind, which actually blows molds away and makes less chemicals necessary. These days, they are planting grapes like muscat, pinot noir and pinot grigio. Joe also mentions tinta cao, a Portuguese varietal often used in port wines, and his hopes for the zinfandel he planted, a grape that will require a lot of attention and love to succeed. "With every good thing, it's got to grow," he says, and we're not sure if he means the winery or the grapes themselves. He's come a long way since he made small batches of wine for a family harvest. Of course, now the family is just a little larger.

We show Joe our tasting notes from previous years, on which we have many of the same details, and mention that the latest Stone House Red tastes like a young Pomerol. He's pleased with the consistency and is proud of his wines. But most of all, he seems proud of the local community he has created seemingly from thin air and the education he is imparting. "I want them to learn that it's not the old way of trying wine anymore. I think the new generations of wine drinkers are totally different. People can drink wine and enjoy wine the way they want to."

Late in the afternoon, we put down our clippers and walk up the long, dusty drive to the churchlike tasting room with patios and porches, beautiful wood beams and natural light. When we first visited Gouveia shortly after it opened, it was half the size. Now, there is space for hundreds of people, who

gather around tables, enjoying the fruits of their labor, nibbling on pasta, cake or hunks of cheese. The harvesters are dirty and sweaty but have a look of satisfaction, like they've earned their glass of cherry vanilla cabernet franc at the end of the day. Our fingers holding the glasses are swollen from carrying crates, and we toast a job well done.

Though the vineyard is the size of Sharpe Hill or Hopkins, Joe sells the vast majority of his wine here at the winery and wants to keep it that way. He also does not host weddings, but other dinners and parties are a constant feature in this beautiful spot overlooking the valley and distant mountains. Dawn says, "That's one of the reasons that Mr. Gouveia picked this spot—he didn't want you to come in, try wine, then leave. That's why he invites people to bring their own food; he wants people to sit up here. This is his home, so he wants people to share it." Today, he is sharing it with almost five hundred people, all eager converts to the new grape culture in their backyards.

Known as *pigeage à pied* in France, stomping grapes by foot has a long tradition, still demonstrated at wineries like Gouveia. *Courtesy of the authors.*

Joe also believes that in another ten years, California's vineyards are going to be seriously challenged by the East Coast, where the vineyards are "just taking off." He spends his free time "reaching out to other people to do grapes" and sees "as many as one hundred vineyards" in Connecticut in the next decade. President of the Wine Trail Jamie Jones agrees: "I'd like to think we're still in the infancy." All the state's winemakers agree that modern vineyards have a lot going for them. It's warmer now than in the 1800s, nurseries do better work and the fungicides are superior. Pioneer Bill Hopkins says, "I hope the future's bright; I think it is." Perhaps Connecticut will fulfill its early promise. Perhaps one day all these hills will come alive with grapes.

The Gouveias set up the barrels for grape stomping, and we head outside to join the fun. Sleeping Giant and the Hanging Hills of Meriden frame the horizon as huge crowds cheer on the tradition. It is only a small part of this larger tradition, the celebration of the harvest, which has been a part of the human experience at least since the agricultural revolution ten thousand years ago. It ties us to not only our own ancestors but also the entire world. In an increasingly urban society, many of us have lost this connection. Perhaps that is the dream of winemakers, to connect us to the land, to the past and to one another. If so, it is a fine dream, and one worthy of a centuries-long pursuit.

On a cold January day, when the forests are deep in snow, we invite our own friends and family to our new house to taste the results of this pursuit. They include some who drink wine every day and some who barely drink. There are some who have never tried local wine, and some who have traveled the entire Wine Trail. There are red drinkers, white drinkers and beer drinkers. All are eager to try something new, and all drink blind. In the vaulted dining room, warmed by the blaze of the nearby wood stove, everyone lifts glasses from Connecticut wineries and swirls, sniffs and sips.

The results are perhaps not surprising given the subjectivity of taste. There is no one wine that everyone dislikes or likes and no agreement on the particulars. Sharpe Hill's Ballet of Angels has, alternatively, a floral, citrus, raspberry or peach nose, depending on who you talk to. The popular, slatey pinot gris from Jones Farm is either sweet or dry and has apple in the nose, the middle or the finish, but not in all three for any one person. Some taste smoky black olives in Priam's Salmon River Red, some pepper—a wine that is "initially very strong, but mellows out as you drink," according to local police officer Ron. Beer enthusiasts Mike and Liz happily take a bottle of it home. We were glad to return the favor; a few years ago, they turned us on to Hopkins's Sachem's Picnic.

Everyone finds a gem in this harvest. Fellow writers Diane and Eric, who prefer "long reds," love Saltwater Farms Merlot, with its "coffee and lead pencil" nose and its warm and satisfying finish. White Silo's Rhubarb surprises many, like Kristen, who tastes apricots. "As good as white wine," says local pastor Doug. Taylor Brooke's "buttered cherry" cabernet franc has "pinot noir softness" to friends Sarah and Ron. They also loved Sunset Meadows' St. Croix, an earthy, spicy wine with a light finish. "Good drinking by the fire with s'mores," Sarah says. My father, David, agrees, saying he "didn't think they had good red grapes in Connecticut," while enjoying the st. croix's blackberry flavor. Maugle Sierra's 1740 Ledyard House Rosé gets a fan in former chef John, who plans to try it with a variety of local dishes. His wife and wine connoisseur Kathryn sums up by saying that it's "nice to see our state is capable of making wine of this quality."

At the end of the day, we hope we have given our family and friends a chance to connect and to enjoy a cold winter day by the warmth of a fire. But hopefully, the results of Connecticut's endeavors in wine have done even more. Perhaps, through the hard work and imagination of vintners and dreamers, we have the chance to understand the importance of the land, of our relationship to it and of the value of home. In doing so, we might help make that home better. We may even find that home is larger than we ever knew and that our family stretches around the world and to the beginning of time.

After all, what are these winemakers doing but extracting the very stuff of life, in all its unbelievable complexity, and pouring it into one bottle? Let us not take that gift lightly. Let us take each opportunity for fellowship and celebration in our intricate, difficult journeys. And, of course, let us share a glass of wine along the way.

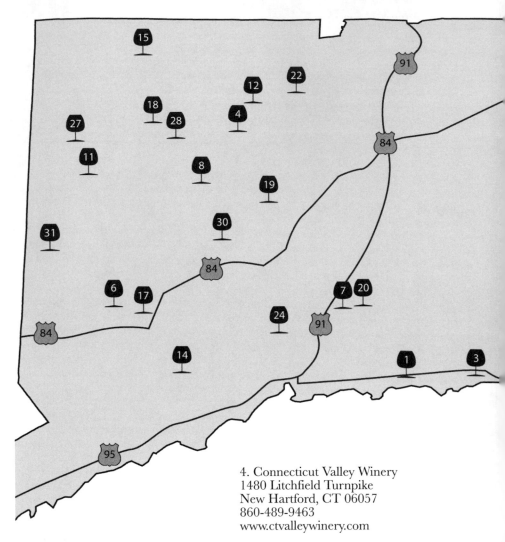

4. Connecticut Valley Winery
1480 Litchfield Turnpike
New Hartford, CT 06057
860-489-9463
www.ctvalleywinery.com

1. Bishop's Orchards Winery
1355 Boston Post Road
Guilford, CT 06437
203-453-2338
www.bishopsorchards.com

5. Dalice Elizabeth Winery
6 Amos Road
Preston, CT 06365
860-930-9198
www.daliceelizabeth.com

2. Cassidy Hill Vineyard
454 Cassidy Hill Road
Coventry, CT 06238
860-498-1126
www.cassidyhillvineyard.com

6. DiGrazia Vineyards
131 Tower Road
Brookfield, CT 06804
203-775-1616
www.digrazia.com

3. Chamard Vineyards
115 Cow Hill Road
Clinton, CT 06413
860-664-0299
www.chamard.com

7. Gouveia Vineyards
1339 Whirlwind Hill Road
Wallingford, CT 06492
203-265-5526
www.gouveiavineyards.com

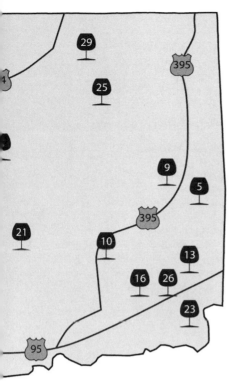

13. Jonathan Edwards Winery
74 Chester Main Road
North Stonington, CT 06359
860-535-0202
www.jedwardswinery.com

14. Jones Winery
606 Walnut Tree Hill Road
Shelton, CT 06484
203-929-8425
www.jonesfamilyfarms.com

15. Land of Nod Winery
99 Lower Road
East Canaan, CT 06024
860-824-5225
www.landofnodwinery.com

16. Maugle Sierra Vineyards
825 Colonel Ledyard Highway
Ledyard, CT 06339
860-464-2987
www.mauglesierravineyards.com

8. Haight-Brown Vineyards
29 Chestnut Hill Road
Litchfield, CT 06759
860-567-4045
www.haightvineyards.com

9. Heritage Trail Vineyards
291 North Burnham Highway
Lisbon, CT 06351
860-376-0659
www.heritagetrail.com

10. Holmberg Orchards & Winery
12 Orchard Lane
Gales Ferry, CT 06335
860-464-7305
www.holmbergorchards.com

11. Hopkins Vineyard
25 Hopkins Road
New Preston, CT 06777
860-868-7954
www.hopkinsvineyard.com

12. Jerram Winery
535 Town Hill Road
New Hartford, CT 06057
860-379-8749
www.jerramwinery.com

17. McLaughlin Vineyards
14 Albert's Hill Road
Sandy Hook, CT 06482
203-426-1533
www.mclaughlinvineyards.com

18. Miranda Vineyard
42 Ives Road
Goshen, CT 06756
860-491-9906
www.mirandavineyard.com

19. Northwinds Vineyard
471 Lake Winnemaug Road
Watertown, CT 06795
203-233-3941
www.northwindsvineyard.com

20. Paradise Hills Vineyard
15 Windswept Hill Road
Wallingford, CT 06492
203-284-0123
www.paradisehillsvineyard.com

21. Priam Vineyards
11 Shailor Hill Road
Colchester, CT 06415
860-267-8520
www.priamvineyards.com

22. Rosedale Farms & Vineyard
25 East Weatogue Street
Simsbury, CT 06070
860-651-3926
www.rosedale1920.com

23. Saltwater Farm Vineyard
349 Elm Street
Stonington, CT 06378
860-415-9072
www.saltwaterfarmvineyard.com

24. Savino Vineyards
128 Ford Road
Woodbridge, CT 06525
203-387-1573

25. Sharpe Hill Vineyard
108 Wade Road
Pomfret, CT 06258
860-974-3549
www.sharpehill.com

26. Stonington Vineyards
523 Taugwonk Road
Stonington, CT 06378
860-535-1222
www.stoningtonvineyards.com

27. Strawberry Ridge Vineyard
23 Strawberry Ridge Road
Warren, CT 06754
860-868-0730
www.strawberryridge.com

28. Sunset Meadow Vineyards
599 Old Middle Street
Goshen, CT 06756
860-201-4654
www.sunsetmeadowvineyards.com

29. Taylor Brooke Winery
848 Route 171
Woodstock, CT 06281
860-974-1263
www.taylorbrookewinery.com

30. Walker Road Vineyards
17 Walker Road
Woodbury, CT 06798
203-263-0768
www.walkerroadvineyards.com

31. White Silo Winery
32 Route 37 East
Sherman, CT 06784
860-355-0271
www.whitesilowinery.com

BIBLIOGRAPHY

"American Viticultural Areas by State." Wine Institute. http://www.wineinstitute.org.

Bendici, Ray. "Agriculture, and Then Some." *Connecticut Magazine* (September 2010): 128.

Bittman, Mark. "Southern New England's Surprising Chardonnays." *New York Times*, August 23, 1995.

Bloom, Lary. "A Case of Connecticut Wining." *Hartford Courant*, January 12, 1997.

Borst, Laurie. "Making His Own Wine and Toasting to Your Health." *Newtown Bee*, October 23, 2007.

Burnsen, Howard. "Thinking about Starting a Small Winery? Here's How a Start-up New England Winery Was Pre-Planned." *Vineyard and Winery Management Magazine* (March/April 1993).

Bushnell, Horace. *An Address Before the Hartford County Agricultural Society, October 2, 1846.* Hartford, CT: Brown and Parsons, 1847.

Chaplin, Bob. "Passport to Connecticut Wine Country." *Decades Magazine* (Spring 2006).

———. "The Taste Test: An Evening of Ambitious Wine-Drinking Yields Some Keepers, Some Sleepers and Some Wine We Were Happy to Spit Out." *Hartford Courant*, November 26, 2000.

Code of Federal Regulations. "§9.122 Western Connecticut Highlands." Alcohol, Tobacco and Trade Bureau Treasury. American Viticultural Areas, 2008.

———. "§9.72 Southeastern New England." Alcohol, Tobacco, and Trade Bureau Treasury. American Viticultural Areas, 2008.

Colin McEnroe Show. "Connecticut Winemakers and Wineries." CPBN, July 22, 2010.

Connecticut Herald. "Lafayette Grapes?" October 5, 1824.

Connecticut Mirror. "Vineyards in the States of New York, New Jersey, and Connecticut." July 9, 1827.

Coraggio, Jack. "Rao's House Wine? It's From Warren." *Litchfield County Times*, March 26, 2009.

Crump, Gary. "Grapes and Wine in Connecticut." *CAES Frontiers of Plant Science* 57, no. 1 (Fall 2006).

Dickerman, J.H. "Prize Essay: Grapes and Wine." In *Sixth Annual Report of the Secretary of the Connecticut Board of Agriculture, 1872*. Hartford, CT: Press of Case, Lockwood and Brainard, 1873.

Donovan, Mary. *The Thirteen Colonies Cookbook.* New York: Praeger, 1975.

Douglas, Sharon M. "Grape Varieties for Connecticut." Connecticut Agriculture Experiment Station, December 1997.

Driscoll, Eugene. "Eagles Soar Over Vineyard." *Fairfield Citizen*, January 21, 2004.

Edwards, Rachel. "Winemaker Spotlight: George Motel III of Sunset Meadow Vineyards." PressNewEngland.com. http://pressnewengland. com/blog/wineries/winemaker-spotlight-george-motel-iii-of-sunset-meadow-vineyards.

Engelhardt, Matthew. "A Grape State: Wine Industry Growing as Trail Expands." *Journal Inquirer*, July 16, 2009.

Faria, Mann. "Connecticut Uncorks a Bubbly First." *News Times*, December 19, 1984.

Giese, W. Gill. "Wine Grape Quality." *Wine Grapes Production Guide for Eastern North America*. Ed. Tony Wolf. Ithaca, NY: Natural Resource, Agricultural, and Engineering Service, 2008.

Giuca, Linda. "It's Harvest Time on the Wine Trail Following the Lure of the Grape." *Hartford Courant*, October 14, 1992.

Gold, Robert. "Newtown Moves to Spur Growth." *Fairfield Citizen*, December 6, 2005.

Goldberg, Howard G. "Chamard, Not Your Ordinary Vineyard." *New York Times*, November 21, 1999.

Hartford Courant. "Barren Old Farm Now a Vineyard." February 13, 1915.

———. "Cider Gives Way to Italian Wine." December 12, 1912.

———. "Connecticut as a Vineyard State." October 24, 1911.

————. "The Farmers Again." August 5, 1919.

————. "Making the Waste Places to Bloom: Swamp and Woods Give Place to Vineyards." October 19, 1913.

————. "Rosedale Farm." September 16, 2009.

————. "Sales of Liquor." March 20, 1903.

Hartford Daily Courant. "Agricultural Fair in Rocky Hills." October 26, 1868.

————. "Agricultural Matters." August 7, 1873.

————. Editorial. November 11, 1858.

————. "Grape Growers' and Vintners' Convention." January 14, 1858.

Heerick, V.P. *A History of Horticulture in America.* New York: Oxford University Press, 1950.

Hooker, Margaret Huntington. *Early American Cookery or Ye Gentlewoman's Housewifery.* Scotia, NY: Americana Review, 1981.

LaMar, Jim. Professional Friends of Wine Website. http://www.winepros. org/wine101/grape_profiles/varietals.htm.

Lanza, Karen. "Have a Grape Time: Amateur Winemakers Gearing Up for Stamford Competition." *Advocate,* October 1, 2009.

Larkin, Jack. "Dining Out in the 1830s." *Old Sturbridge Village Visitor* (Spring 1999).

Law, Jim. *The Backyard Vintner: An Enthusiast's Guide to Growing Grapes and Making Wine at Home.* N.p.: Quarry Books, 2005. Available online at http://www. grapegrowingguide.com/grape-planting.html.

Levy, Jarlan. "Made, Not Necessarily Grown, in Connecticut." *New York Times,* May 9, 2004.

Lippincott, James S. "Climatology of American Grape Vines." Agricultural Report. Executive Documents, United States Congress. 1862–63.

Meriden Record-Journal. "Homemade Wine Tasting Contest Took Place in Southington." August 17, 2009.

Monetti, Rich. "McLaughlin Vineyards in Sandy Hook Connecticut." July 28, 2009.

Moran, John M. "Nutmeg State Has Taste for Wine; Connecticut Growing More Vineyards." *Hartford Courant,* October 1, 2005.

————. "State Allows Broader Wine Sales; Small Vineyards Can Ship to and from Connecticut." *Hartford Courant,* July 16, 2005.

Nail, William. "Evaluation of Winegrape Cultural Practices in Connecticut." *Agricultural Experiment Station Bulletin,* 2009.

————. "Grapevine Cultivation in Connecticut." *Agricultural Experiment Station Bulletin,* May 2007.

New York Times. "An '87 Chardonnay that Hit the Spot." December 3, 1989.

Norwich Courier. "Cultivation of the Grape Vine." August 27, 1828.

O'Connor, Sharon. *Tasting the Wine Country*. Emeryville, CA: Menus and Music Productions, Inc., 2001.

Phipps, Frances. *Colonial Kitchens—Their Furnishings and Their Gardens.* New York: Hawthorn Books, Inc., 1972.

Rice, Kym S. *Early American Taverns: For the Entertainment of Friends and Strangers.* Frances Tavern Museum. Chicago: Regency Gateway, 1983.

Schuette, Alice. "A Taste of New England Along the CT Wine Trail: DiGrazia Vineyards of Brookfield." *Brookfield Patch*, September 26, 2010.

Shea, Lisa. "Hybrid vs. Cross vs. Blend." http://www.wineintro.com.

Sommers, Brian J. *The Geography of Wine: How Landscape, Cultures, Terroir and Weather Make a Good Drop*. New York: Plume, 2008.

Spencer, Benjamin. "The Perfect Vintage: A Merging of Luck and Opportunity." http://www.Intowine.com.

Thompson, Joel C. "Local Vintners Debate Homemade Wine." *Connecticut Post*, August 30, 2007.

Walden, Joan. "Escape to Connecticut's Wine Country." *Hartford Courant*, September 16, 2009.

Waller, Ann. "Dr. Kiyomoto Named Connecticut Wine Trail's Person of the Year." *New England Wine Gazette* (Spring 2010): 3–4.

"Wine Consumption in the U.S." Wine Institute. http://www.wineinstitute.org.

"Wine Industry Data." National Association of Wineries. http://www.wineamerica.org.

Wolf, Tony K. *Wine Grapes Production Guide for Eastern North America*. Ithaca, NY: Natural Resource, Agricultural and Engineering Service, 2008.

Wong, Stacy. "Heard It through the Grapevine: Connecticut Wine Trail Shows Off Fruits of State's Vintners." *Hartford Courant*, May 8, 1997.

Personal Interviews with the Authors

Agnelli, Lauren. October 8, 2010.

Auger, Linda. June 2, 2010.

Baker, James. August 16, 2010.

Ballou, Debbie, and Steve Kaye. July 13, 2010.

Chatey, Louis, and Margaret Chatey. June 3, 2010.

Connery, Michael M. July 17, 2010.

Crump, Gary, and Gloria Priam. July 26, 2010.

Edwards, Jonathan. July 16, 2010.

Fein, Bob. July 8, 2010.